THE WORLD'S SIMPLEST
Photography Book

Jerry Hughes

Phillips Lane Publishing
5430 LBJ Freeway, Suite 1600
Dallas, Texas 75240
214-788-2995

D1377913

First Edition, December 1992

Second Edition, November 1993

Text and Photographs Copyright © 1993 by Jerry Hughes Photography, Inc.

Compilation Copyright © 1993 by Jerry Hughes Photography, Inc.

Published in the United States by Phillips Lane Publishing

ISBN 0-9634348-3-7

Forward

A story is told of a famous photographer being asked, " Sir, what kind of camera do I buy my son so he takes photographs like you?" The photographer looked at the man and replied, " What kind of piano would you buy him so he could play like Mozart?"

Knowing how to use equipment is usually more important than the equipment. Using a camera without knowledge is like using a computer without software; it is just a machine that needs to be told what to do. After you finish reading this book, read your camera's manual again; it should make more sense. You should know all you can about your camera.

Automatic cameras can only do two things. They focus and set the exposure for you. The cropping, composition, camera angle, lighting, lens choice, etc. are up to the photographer.

Only you, the photographer, can decide how to crop your subject and where to place it. You choose your camera height and walk around to find the best angle for the lighting, background and subject. You choose which film to use and the lens that will make your subject look best. This book deals with the artistic side of photography and will work with any camera.

The photographs in this book are in black and white because it the best way to teach photography. The fundamentals of lighting, composition, camera angle, lens choice, etc. are easier to see as well as the difference between good and bad examples.

Starting out, I had many questions, attended many seminars, tried things and made mistakes. In this book I have tried to explain the most useful information as simply as possible. No photograph is perfect so if you are on vacation and standing in front of Buckingham palace, don't refuse to take a shot just because the lighting is bad. Photographs are for memories as well art.

The principles in this book will help you take great photographs. If you decide to go against them and try another way sometimes that's okay. You must first know the rules to break them correctly.

Very Truly,

Jerry Hughes

Thanks to Dad and Mom
for all the love and support.
Love,

Jerry

Contents

Guide to Sketches in this Book

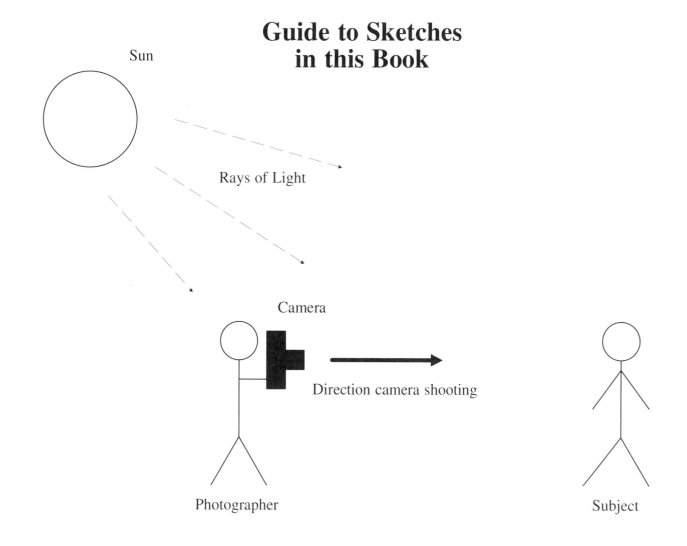

Sun

Rays of Light

Camera

Direction camera shooting

Photographer

Subject

Cropping

How much you show of the subject

Composition

Where you place the subject

You can crop and compose your subject *by thirds*. Try to use both cropping and composition together to create your photograph. Crop your subject by thirds and fill the frame with it. Compose your subject by placing it on a 1/3 line.

You can crop your photograph while shooting or when having it printed. If you want to show only the subject, get closer to *fill the frame* with it. You can show the full subject or crop it by thirds. A person can be photographed 3/3 (full length) from the head to feet, 2/3 from the head to mid thigh, or 1/3 from head to chest. If the subject fills the frame, it is ok to center it.

If you want space around your subject and don't want to fill the frame, compose your photograph by *placing* your subject on a 1/3 line.

You can place the subject on the left or right third, top or bottom third line. Where the *1/3 lines* cross is called a Hot Spot and is a good place for the subject.

For scenic shots, the horizon should be placed on the top or bottom third line. A photograph of a field of flowers with blue sky and clouds, you could show more field and less sky or more sky and less field.

Most people tend to put the subject in the focus circle and leave it there to shoot. The *focus circle* is for focusing not composing. Centering the subject in the focus circle leaves half the photograph empty and is generally bad composition.

Compose your photograph, focus and then shift back to compose again and shoot.

Three Basic Formats

■ Vertical, Horizontal and Funky Tilt

Find the Best Format:

Which way does your subject look best? Looking at it with the camera vertical, horizontal or at a funky tilt. Try photographing it more than one way.

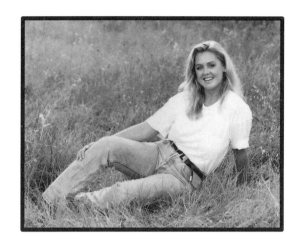

Horizontal

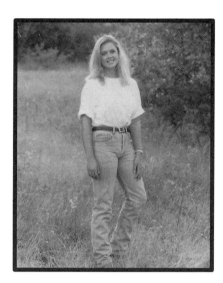

Vertical

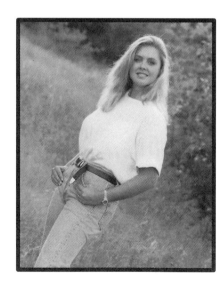

Funky Tilt

The Thirds Principle

■ Cropping

Crop the Subject by Thirds:

Cropping is choosing how much of the subject and area you want to show. Try to crop the subject by thirds, 3/3 full length, 2/3 or 1/3.

■ Composition

Place the Subject on a Thirds Line:

Composition is choosing where to place your subject in the photograph. Try to place the subject on a thirds line on the left or right, top or bottom.

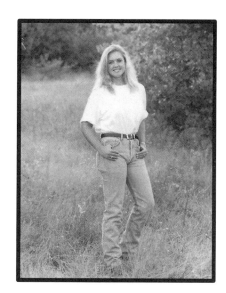

If the subject fills the frame it's ok to center it

If there is a lot of space around the subject, try to place the subject on a thirds line

Common Mistake

■ Focusing Circle

Don't Center Subject in Circle:

The circle in the middle of your viewfinder is for focusing; don't use it to place your subject. If you put your subject in the circle, it will center it and leave the photo half empty. When the subject is centered it is placed on a half not a third where it should be.

Use the focus circle to focus, not to place your subject

Subject's head centered in focus circle, and top half of photo is empty

9

Fill Frame
With Subject

■ Cropping by Thirds

3/3, 2/3 or 1/3 Crop:

Fill the frame with the subject cropping it to show 3/3 (full length), 2/3 or 1/3 of the subject.

Cropping Note:

Look at television, movies, magazine covers and advertisements to see how they *crop* the subject by thirds.

Three Third
(Full Length)

Two Third

One Third

1/3

2/3

3/3

Crop Loosely or Tightly

■ Artistic Choice

Creative Option:

You can crop the subject loosely or tightly by thirds.

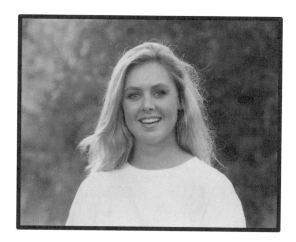
Loose crop

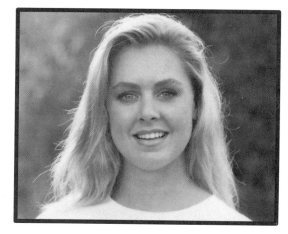
Tight crop

Crop in for Details

■ Recording Details

Looking Closer:

Crop in on the subject to show interesting details. This can be done with a house, street scene, etc. You can shoot an overall shot and then come in close for different parts of the scene.

Details

Details

Details

Placing Subject in Frame

■ Left or Right Third

Place the Subject on a 1/3 Line:

Place the subject or center of interest in a scene on the left or right 1/3 line.

Left 1/3 line

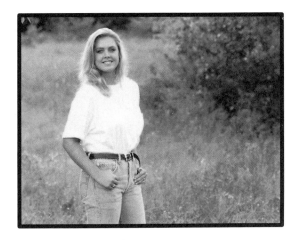

Left 1/3 line

Right 1/3 line

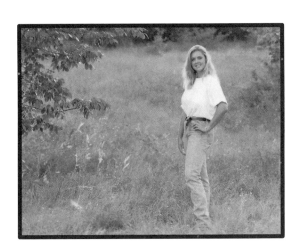

Right 1/3 line

Placing Subject in Frame

■ Top or Bottom Third

Place the Subject on a 1/3 Line:

Place the subject or center of interest in a scene on the top or bottom 1/3 line.

Composition Note:

Look at television, movies, magazine covers and advertisements to see how they *place* the subject in the frame on a thirds line.

Top 1/3 line
Shows less background
and more foreground

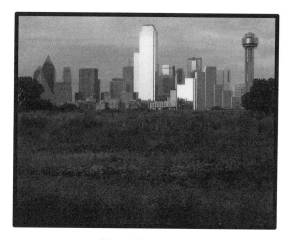

Top 1/3 Line
Shows less background
and more foreground

Bottom 1/3 Line
Shows more background
and less foreground

Bottom 1/3 Line
Shows more background
and less foreground

13

Composition
Hot Spots

■ Where 1/3 Lines Cross

Place Subject on a Hot Spot:

Try to place your subject or center of interest in a scene on a Hot Spot where the 1/3 lines cross.

Top / Left Hot Spot

Bottom / Left Hot Spot

Bottom / Right Hot Spot

Top / Right Hot Spot

Composition
Hot Spots

■ Where 1/3 Lines Cross

Place Subject on a Hot Spot:

Where the 1/3 lines cross are called Hot Spots. There are four Hot Spots in the frame. Placing your subject on a Hot Spot is good composition.

The Four Hot Spots

Top / Right Hot Spot

Top / Left Hot Spot

Bottom / Right Hot Spot

15

Viewfinder Camera

■ Looking Through a Viewfinder

Separate View from Lens:

With most point-and-shoot cameras you look through an opening above the lens and see close to what the lens sees, but not exactly the same view. Be careful not to get closer than your cameras minimum focusing distance. Most viewfinder cameras come with a wide-angle lens that pushes the subject farther away than it looks.

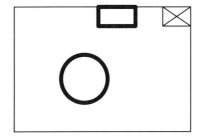

Front view of viewfinder

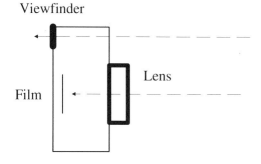

Side view of viewfinder

Single-Lens Reflex Adjustable Camera

■ Looking Through the Lens

Same View as Lens:

Single-lens reflex cameras have a mirror mechanism that acts like a periscope to let you see through the lens. The mirror flips up when you take the photograph and then back down for the next photograph.

Front view of single-lens reflex

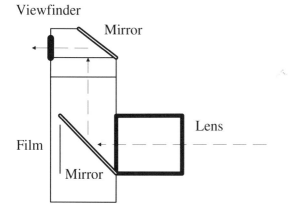

Side view of single-lens reflex and cutaway view to show mirrors

Cropping Into People's Heads

■ Viewfinder vs Lens

What You See & What the Lens Sees:

With viewfinder cameras you look through a viewfinder not the lens. When you get in close, there can be trouble with the viewfinder higher than the lens it can crop into the top of the photograph. There are black or faint yellow lines in the viewfinder that mark where the edge of the photo will be. You need to be careful to keep your subject within these lines.

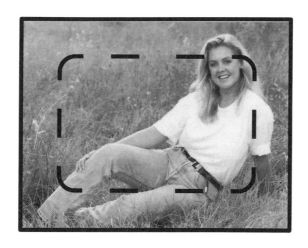

WHAT YOU SEE
Cropping guides show
edge of photograph

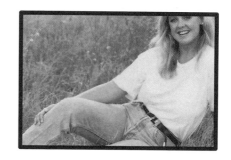

WHAT YOU GET
Photograph showing what
was inside cropping guides

Caps, Straps and Fingers

■ Things in Front of the Lens

Be Careful:

Since you aren't looking through the lens, you won't see, your fingers or the camera strap in front of the lens. Take the lens cap off, too.

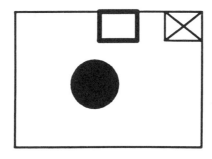

Lens cap is on

Camera strap in front of lens

Finger in front of lens

17

Compose, Focus, Shift and Shoot

■ Cropping

Filling the Frame with the Subject:

Crop so the subject fills the frame. Focus on the subject. Shift back to fill the frame and shoot.

1. Fill frame with subject

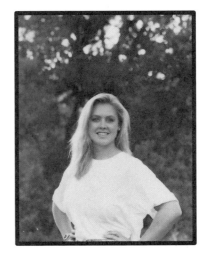

2. Shift to focus on subject

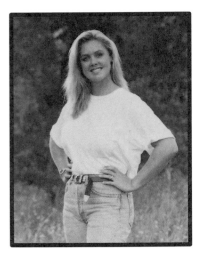

3. Shift back to fill frame and shoot

■ Composition

Placing the Subject in the Frame:

Place your subject in the frame on a thirds line. Focus on the subject. Shift subject back to thirds line and shoot.

Autofocus Cameras and Focus Lock:

If your subject is off center and you are using an autofocus camera, you may need to use the focus lock feature. This lets you hold the focus on the subject even when it isn't centered.

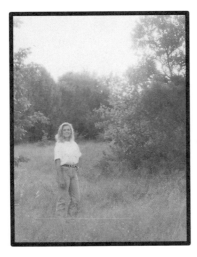

1. Place subject on 1/3 line

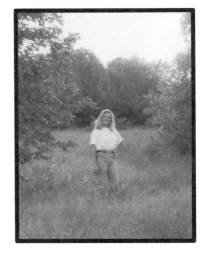

2. Shift to focus on subject
(If autofocus use focus lock)

3. Shift back to place subject on 1/3 and shoot

Cropping & Composition

◼ Summary

Try Three Formats:

Photograph your subject vertically, horizontally and at a funky tilt.

Filling the Frame:

Photograph your subject filling the frame, full length and then crop it by 2/3 and 1/3.

Placing the Subject:

Photograph your subject placed on the left or right 1/3 line. Photograph your subject on the top or bottom 1/3 line. You can try to place the subject on a Hot Spot where the 1/3 lines cross.

Improve Your Skills

1. Format subject horizontally
2. Format subject vertically
3. Format subject funky tilt
4. Crop subject 3/3 (full length)
5. Crop subject 2/3
6. Crop subject 1/3
7. Tight crop
8. Crop in for details
9. Place subject on left third of frame
10. Place subject on right third of frame
11. Place subject on top third of frame
12. Place subject on bottom third of frame

Mini Quiz

1. There are _____ basic formats you can use for a photograph.

2. The subject looks best cropped by _____.

3. For composition, the subject looks best placed on the ____ or right third or the top or _____ third.

4. When the subject or center of interest is at an intersection of 1/3 lines it is on a ___ Spot.

5. Use _____ and _____ together to create a great photograph.

(1. three 2. thirds 3. left, bottom 4. hot 5. cropping, composition)

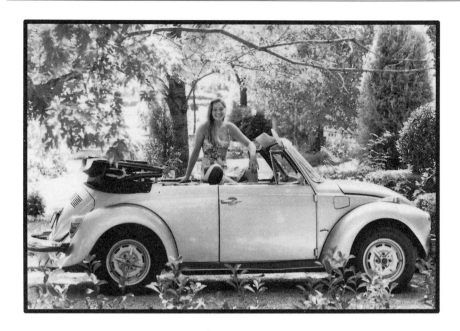

Walk-Around Camera Angles

The camera angles you see as you walk around your subject

Everything *changes* as you walk around your subject. 1. The view of the subject changes. 2. The background changes. 3. The lighting changes.

You may want to shoot a safe shot from your first angle and then look for a better angle. Most people think they know what it will look like from another angle, but never *go look* and see. They get the shot everybody else does. It may be just a slight change in camera angle that makes the difference.

If you can move your subject, first look for the *best* walk-around camera angle for the lighting. In direct sunlight, I usually start by putting the sun behind my subject. Next try to find the best background to go with the lighting. Then place your subject turned to its best angle.

Some subjects are *easier* to walk around than others. Don't spend all day walking around a mountain to see what is on the other side (unless you have the time.) Some great angles and shots just fall in your lap, so be ready. Be careful trying to find the best angle, it's not worth getting hurt.

The lighting and shadows will change as you walk around your subject. Look at an object in your home and see how the *shadows change* as you change your angle to the light from a lamp.

A telephoto shows less *background* behind the subject than a wide-angle lens of the same view. The background should bring attention to the subject not distract from it. Avoid telephone poles, etc., sticking out of peoples heads.

Walk-Around Camera Angles

■ Walk and Look

Look Around:

Walk around your subject to see how it looks from different angles. Don't just imagine, take a look. You may be surprised by what you see and get a great photograph. Try shooting from several different angles.

Lighting, Background and Subject

■ The Challenge

Find the Angle Best for all Three:

The lighting, background and subject will change as you walk around the subject and look at it from different angles. At one angle the light may be great, but the background's bad or it's not the subject's best side. You may have to work harder with some situations to find the best angle for all three.

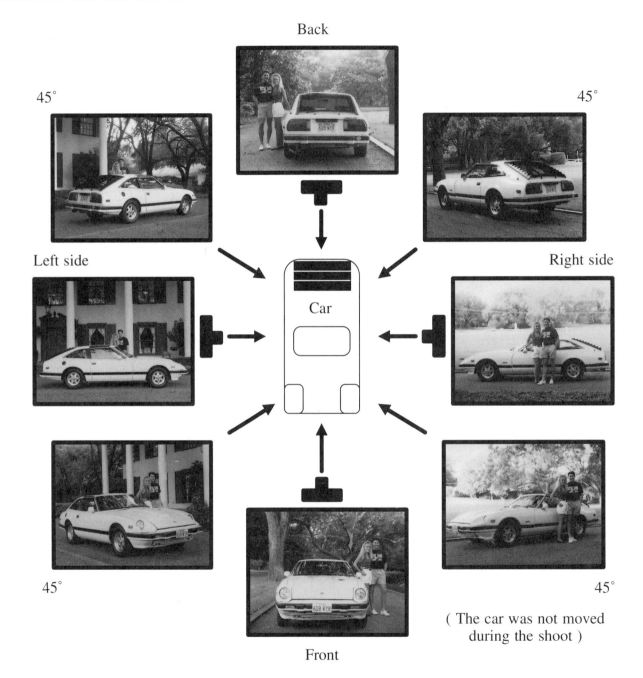

Walk-Around Camera Angle to BACKGROUND

■ Distractions

Attention on Subject:

Try to find the least distracting background. Avoid trees and telephone poles coming out of peoples' heads.

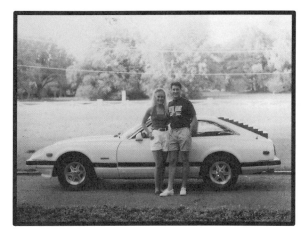
Background distracting

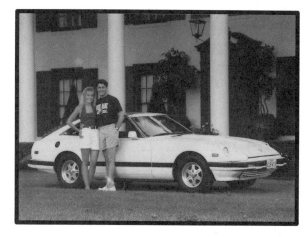
Background less distracting

Cropping the Background

■ Wide-Angle vs. Telephoto Lens

More or Less Background:

A wide-angle lens has a wide view. It shows more background behind the subject. A telephoto lens has a narrow view. It shows less background behind the subject. Count the number of columns behind the car.

Wide-angle lens / Shows more background

Telephoto lens / Shows less background

23

Walk-Around Camera Angle to LIGHT

■ Cameras Angle to Light Source

Direct or Back Light:

You get direct light photographing with the sun in front of the subject. You get back light photographing with the sun behind the subject.

Direct light
Sun in front of subject

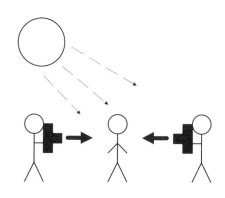

Back light
Sun in back of subject

Camera Angle to Light

■ Shadows Change

Changing Camera Angle to Light:

As you walk around the subject the light and shadow areas will change as your angle to the light changes. This will happen in direct sunlight or shade.

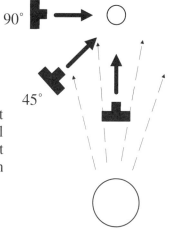

90°

45°

Birds eye view
Walking around subject

Camera in line
with light

Camera angle 45°
to light

Camera angle 90°
to light

Walk-Around Camera Angle to SUBJECT

■ Moveable Subject

Lighting and Background First:

Look for the best angle for the lighting and background. Then place your subject there with its best side turned to the camera.

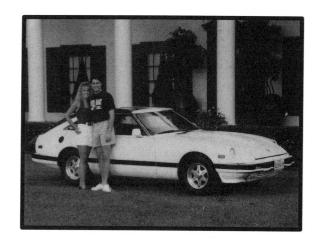

1. Find best lighting 2. Find best background 3. Place subject at best angle

■ Non-Moveable Subject

Scenic: Small Move - Big Change

Even a small change of moving 15 feet to the left or right can make a big change in the foreground, middle ground and background of a scene. The cactus position to the mountain ridge changed and the foreground changed from small cactus to sage brush. You don't have to walk around the mountain to make a difference.

← Photographed 15 feet apart →

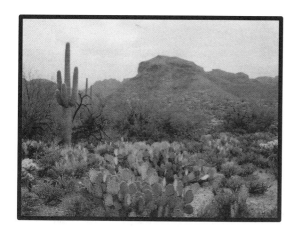 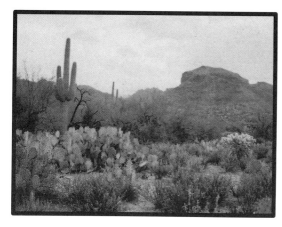

Mountain ridge closer to tall cactus with small cactus in foreground Mountain ridge farther from tall cactus with sage brush in foreground

25

Walk-Around Camera Angle in Shade

■ Creating Shadow

Shoot Along Shade Line:

Instead of photographing someone in front of a wall, try shooting down the side of the wall. This will create shadows on the subject and give a different background.

Birds eye view of wall and subject

Down side of wall

Straight at wall

Light on Dark Dark on Light

■ Principle

Separating Subject from Background:

A light subject on a dark background or a dark subject on a light background will stand out. You can try light on light and dark on dark to blend the subject and background.

| Dark on Light | Dark on Dark | Light on Light | Light on Dark |

Walk-Around Camera Angles

■ Summary

Walking:

Try walking around your subject to see how it looks from the front, sides and back.

Subject:

Look to see how the view of the subject changes.

Background:

Look to see how the background changes.

Lighting:

Look to see how the lighting changes.

Improve Your Skills

1. Front of subject
2. 45° to front of subject on right side
3. Right side of subject
4. 45° to back of subject on right side
5. Back of subject
6. 45° to back of subject on left side
7. Left side of subject
8. 45° to front of subject on left side
9. Photograph best angle for lighting
10. Photograph best angle for background
11. Photograph best angle for subject
12. Photograph best angle for all three

Mini Quiz

1. The _____ changes as you walk around the subject.

2. The _____ changes as you walk around the subject.

3. The _____ changes as you walk around the subject.

4. The challenge is to find the best _____ for all three.

5. With a moveable subject, you can place it in a good location, at a good angle to the light. If the subject is ___ _____ you may have to wait for the best time of day for good lighting.

(1. background 2. lighting 3. subject 4. angle 5. not moveable)

Camera Height

The camera's height to the subject

Most people don't change their camera height, they just shoot everything *standing up*. How tall they are determines the camera's height. All of their photos look alike; because they were all shot from the same height. Look at the subject from a low, normal and high angle.

A normal angle has very little tilt to the camera. This may mean getting down on your *subject's level* to shoot straight ahead. A normal angle avoids distortion, and most people would rather not be distorted in a photograph. You don't need a really high or low angle to be dramatic, most creative shots are made with a normal angle straight ahead.

If your subject is *tilted*, you may match the tilt with the camera. The rule is keep the camera back parallel to the subject for a normal angle to avoid distortion. A little tilt is OK.

Low and high camera angles can give a different view of the subject. The bigger the tilt, the more the subject is *distorted*.

A wide-angle lens expands a scene and distorts it more than a telephoto lens which compresses a scene.

A high or low angle can add drama to a scenic shot. You may get some distortion and an interesting view of the subject.

You can notice the distortion in a skyscraper as you shoot up at it. The top of it will be smaller as the lines converge upward.

The camera's height to the light changes the *shadows*. Look at an object in your home, stand at the same height as a lamp and then higher and lower angles to see how the shadows change.

29

Camera Height and Angle

■ Three Camera Angles

Low, Normal or High Angle:

A low angle tilts the camera up. A normal angle is straight ahead, with no tilt. A high angle tilts the camera down at the subject.

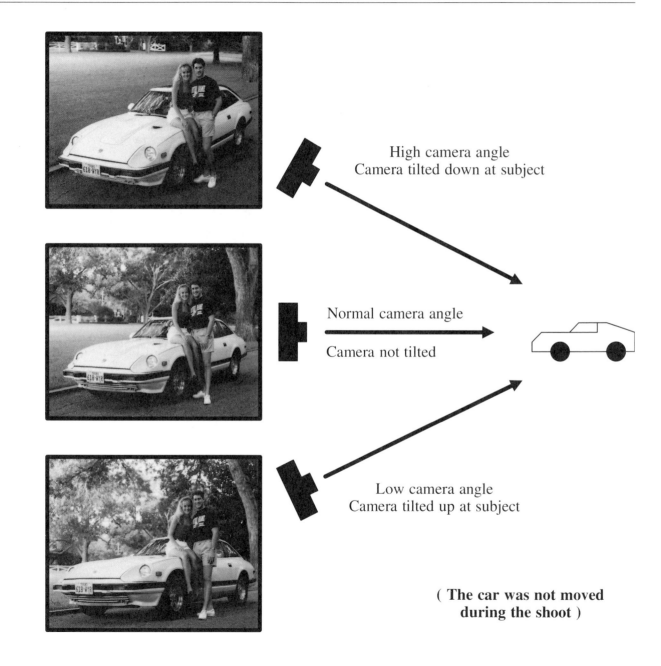

High camera angle
Camera tilted down at subject

Normal camera angle

Camera not tilted

Low camera angle
Camera tilted up at subject

(The car was not moved during the shoot)

Camera Height
to BACKGROUND

■ Background Distracts

Attention on Subject:

Adjusting the camera height can keep the background from distracting attention from the subject.

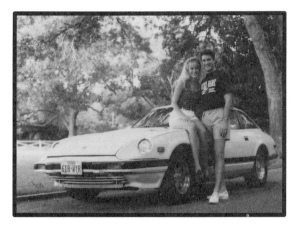

Distracting background

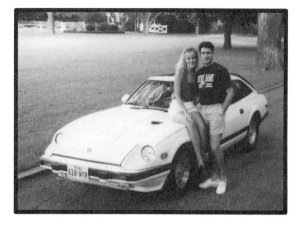

Less distracting background

■ Scenics

Small Change - Big Difference:

Changing the camera height will change the view of your scenic. The difference shown here was from the photographer sitting on the ground, standing and standing on a tree stump.

The low, normal and high angles changed the foreground, background and view of the scenic. Try looking at more than one view.

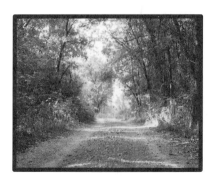

Low Angle

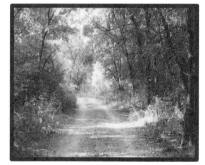

Normal Angle

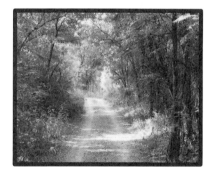

High Angle

Camera Height to LIGHT

■ Camera from Light, Below Light or Way Below Light

Shadows Change:

There will be no shadows if you photograph at the same height as the light. Positioning the camera angle higher or lower than the light will change the shadows.

■ Light Source

Outdoors or Indoors:

The light could come from a lamp, a candle, the sun, a window, etc. Try changing your height to the light and watching how the shadows change.

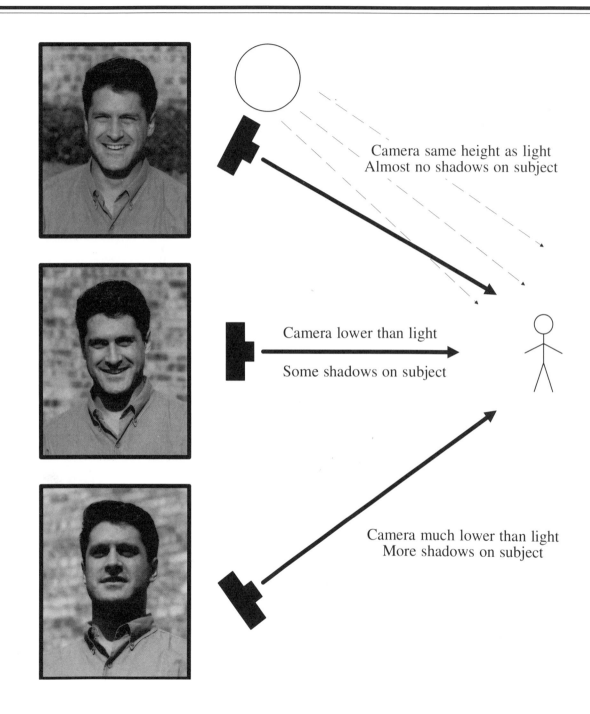

Camera same height as light
Almost no shadows on subject

Camera lower than light

Some shadows on subject

Camera much lower than light
More shadows on subject

Camera Height to SUBJECT

■ Normal Camera Angle

Camera not Tilted:

Adjust your camera height so your camera is not tilted up or down and you are shooting straight on at the subject. Not tilting the camera prevents distortion.

Normal camera angle
Camera not tilted

■ High or Low Camera Angle

Camera Tilted:

Change camera height for a low angle with the camera tilted up, or a high angle tilted down at the subject. Tilting the camera can cause distortion.

Low camera angle
Camera tilted up

High camera angle
Camera tilted down

Portrait: Use Normal Camera Angle

■ Not Tilted

Adjust Camera Height to Subject:

You may have to kneel down to get on a child's level, a person sitting, a pet, etc. This will give you a normal camera angle with no tilt. People look best with a normal camera angle that prevents distortion.

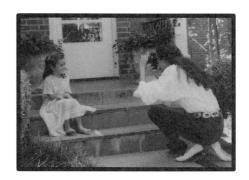

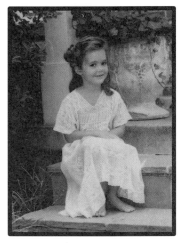

Photographer standing
Camera tilted down
Subject is distorted

Photographer kneeling to
subject's level

From kneeling position
Camera not tilted
No distortion

Wide-Angle vs. Telephoto

■ High and Low Angles

Tilting and Distortion:

A wide-angle lens will distort and stretch the subject more than a telephoto lens. The more a lens is tilted the more there is distortion.

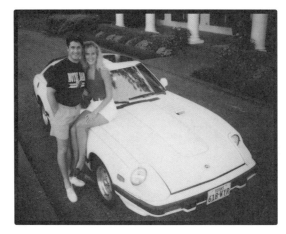

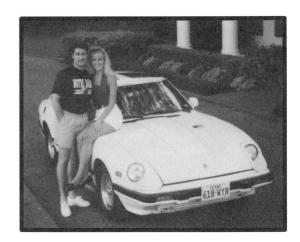

Tilting a wide-angle lens
More distortion

Tilting a telephoto lens
Less distortion

Camera Height

■ Summary

Subject:

Try looking at your subject from a low, normal and high camera angle to see how it changes.

Background:

Try looking to see how the background changes from a low, normal or high camera angle.

Lighting:

Try looking at the lighting to see how it changes with a low, normal or high camera angle.

Improve Your Skills

Person

1. Low angle using a wide-angle lens

2. Normal angle using a wide-angle lens

3. High angle using a wide-angle lens

4. Low angle using a telephoto lens

5. Normal angle using a telephoto lens

6. High angle using a telephoto lens

Scene

7. Low angle using a wide-angle lens

8. Normal angle using a wide-angle lens

9. High angle using a wide-angle lens

10. Low angle using a telephoto lens

11. Normal angle using a telephoto lens

12. High angle using a telephoto lens

Mini Quiz

1. Shooting from a ___ angle the camera is tilted up at the subject.

2. Shooting from a ____ angle the camera is tilted down at the subject.

3. Shooting from a _____ angle the camera is not tilted.

4. Portraits are generally best taken from a _____ angle with a telephoto lens because there is less distortion.

5. A wide-angle lens causes ____ distortion when tilted than a telephoto lens.

(1. low 2. high 3. normal 4. normal 5. more)

35

Four Types of Light

Direct sunlight, Backlight, Shade and Diffused sunlight

There are basically *four types* of natural light, each with its own unique qualities. Being able to identify them and work with them puts you in control. Learn to see light and know how it photographs.

Direct Sunlight: The sun is in front of the subject shining directly on it. Direct sunlight is *usually* too harsh depending on the time of day and its angle. " Put the sun in their faces " is an old wives' tale. Direct sunlight is usually too harsh for people.

There are three types of indirect lighting: backlight, shade and diffused light.

Backlight: The sun is *behind* the subject, and it is standing in its own shade. The light on it is reflected from the surrounding area. A *rim of light* in the hair usually identifies backlighting.

Shade: Direct sunlight is *blocked* by an object. The light in shade is reflected from surrounding areas.

Diffused Light: Direct sunlight is softened when it passes through clouds on a cloudy day. Direct light is *softened* by dust particles in the atmosphere with the long rays of sunrise and sunset.

The lighting may be soft with clouds, but at noon the *angle* will still be too high. People in these photos may have dark shadows under their eyes. Sunrise and sunset have a great low angle of light and are *favorite* times of day for scenic and fashion photographers.

You can plan a shoot by knowing what time of day the light will be best at a location.

Direct Light

■ Sun in Front of Subject

Subject Facing Sun:

Sun is behind the photographer and shining directly on the subject.

Old Wives' Tale

■ ~~Put the Sun in People's Faces~~

Direct Sunlight too Harsh:

Direct sunlight is too harsh for photographing people. When photography first started, film wasn't very sensitive and needed a lot of light. People were told to put the sun in people's faces to make sure there was enough light for the film.

Today's film is sensitive enough that you don't need direct sunlight in someone's face to take a photograph. Direct sunlight can make harsh shadows on the face and people have to squint their eyes to look in its direction.

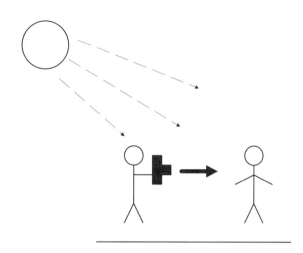

Sun in front of subject

Close up of subject in direct sunlight
(Same subject on next five pages)

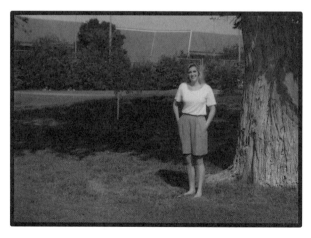

Overall scene in direct sunlight

Back Light

■ Sun Behind the Subject

Photographer Facing Sun:

Sun is in front of the photographer and shining on the back of the subject.

■ Tricky Lightmeter Reading

Adjust for Bright Backgrounds:

If the background is bright behind the subject, it can fool the camera's light meter. Use the backlight or spotmeter button on your camera to help it set for the light on the subject not the background. See page 56.

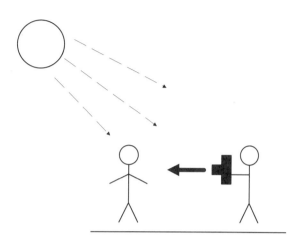

Sun behind subject

Close up of subject in backlight
(Creates a rim of light on subject's hair)

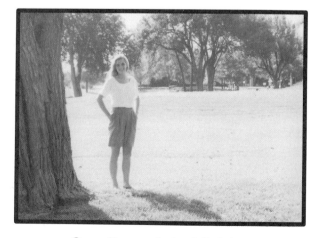

Overall scene in backlighting

39

Shade

■ Subject in Shade

Direct Sunlight Blocked:

An object blocks the sunlight to create shade for your subject.

■ Softens Light

Indirect Light:

The direct sunlight is blocked and light is reflected off the sky and surrounding objects into the shaded area for softer light.

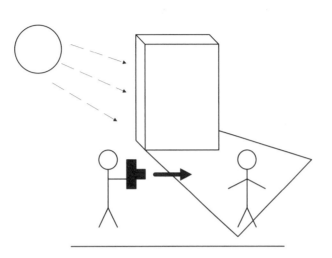

Sun blocked to create shade

Close up of Subject in Shade

Overall scene in shade

Diffused Light Clouds

■ Sunlight Diffused by Clouds

Clouds Soften Light:

The suns rays are softened when they pass through a cloud. Clouds soften the light ratio.

■ Angle of Light

Bad Angle causes Bad Shadows:

Light at high noon may be softer on a cloudy day than it is with direct sunlight, but its direction will still cause deep shadows under a person's eyes.

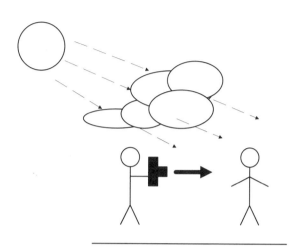

Sun diffused by clouds

Close up of subject on a cloudy day

Overall scene on a cloudy day

41

Diffused Light
Sunrise and Sunset

■ Sunlight Diffused by the Atmosphere

Long Light Rays and Dust:

The sun's rays travel a longer distance at sunrise and sunset. They pass through dust particles in the atmosphere that soften them. The light has a good ratio, direction and warm glow at sunrise and sunset.

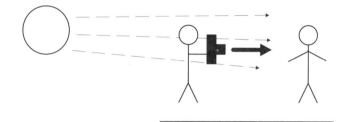

Sun diffused by dust in atmosphere

■ Summer or Winter

Long or Short Sunset:

The good light in the summer before sunrise and after sunset may last 30 minutes; in the winter, it may last two or three minutes. The sun is only soft enough to use directly on people as it is going down or coming up. You can use it as backlight before then. You can use your own judgment on scenics.

Close up of subject at sunrise

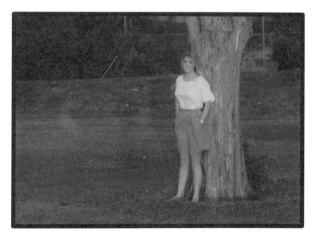

Overall scene at sunrise

Four Types of Light

■ Summary

Identify and Photograph:

Try to photograph moveable and non-moveable subjects in each of the four types of light.

1. Direct Sunlight:

Place your subject in direct sunlight with the sun in front of it. Look at the light and shadows.

2. Backlight:

Place your subject in backlight with the sun behind it. Look at the light and shadows.

3. Shade:

Place your subject in shade with the sun blocked by another object. Look at the light and shadows.

4. Diffused Light:

Place your subject in sunlight diffused by clouds or the atmosphere at sunrise and sunset. Look at the light and shadows.

Improve Your Skills

1. Person in direct sunlight
2. Person in backlight
3. Person in shade
4. Person on cloudy day
5. Person at sunrise or sunset
6. Scene in direct sunlight
7. Scene in backlight
8. Scene in shade
9. Scene on cloudy day
10. Scene at sunrise or sunset
11. Photograph in line with sun in direct light
12. Photograph at angle to sun in direct light

Mini Quiz

1. _____ light is generally the most common light people use but can be harsh.

2. _____ light is softer than direct light and can be had simply by changing the camera angle.

3. _____ is indirect light and created by light reflected into the area.

4. _____ diffuse the light to soften it, but be careful when the angle may be too high at noon.

5. _____ and _____ have soft light and provide a good direction for the light.

(1. Direct 2. Back 3. Shade 4. Clouds 5. Sunrise, sunset)

43

Time of Day

The time of day affects lighting conditions and the angle of light

Early morning and late afternoon are good times of day to shoot because the angle of light is *lower*. You usually want a light angle of 40° or less for better shadows on your subject. Direct light in the morning and afternoon is less harsh than at noon for better light to shadow ratios.

Backlighting your subject with a low light angle creates a rim of light. At noon the top light on the subject "burns" the top of the subject white with no detail.

A lower angle of light creates more *shadow areas* to work in. There are also more shaded background areas.

You may get flare in the lens using backlighting when the sun is low. You can *block* the light using a lens shade, your hand, standing in shade or changing your camera angle.

Sunrise and sunset are used by scenic and fashion photographers because of the soft warm light it produces at a low angle.

Noon is a hard time of day to shoot because the *high* angle of light creates bad shadows on your subject. Direct light at noon is harsh with generally bad light ratios.

The high angle of light at noon creates less shaded areas to work in. There are also less *background* areas in shade.

Sometimes great light happens if you wait and are ready for it.

Knowing the light at different times of day can help you plan.

Don't refuse to take a shot of Buckingham Palace just because you are there at noon and the light isn't perfect. Photographs are *memories* as well as art.

Time of Day

■ Angle of Light to the Subject

Sun Low or High in the Sky:

The time of day determines the sun's height and the light's low or high angle to the subject.

All four photographs are of the same subject in direct sunlight. The low angle looks best but lighting tools can be used to control the light at any time of day.

Noon

Mid Morning

Early Morning

Sunrise

Planning a Photo Shoot

■ Direct or Backlight

Sun in Front or Behind Subject:

If a subject you can't move is in direct light in the morning, it will be in back light in the afternoon and vice versa.

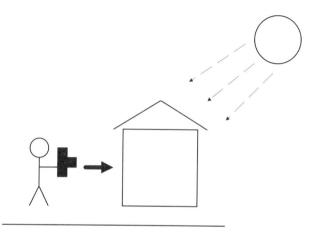

If the sun is in front of an object in the morning
Then the sun will be behind the object in the afternoon

■ Time of Day as a Lighting Tool

Scenic: Choosing Best Time of Day

What is the best time of day for the light on the subject and background? Try to find out the direction your subject area faces and the direction the light will be coming from. You may find locations that work best at a certain time of day.

You can't control the lighting on a mountain so you may need to come back at a better time of day to get the lighting you want. The weather and time of year can also make a difference.

 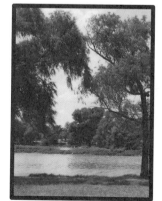 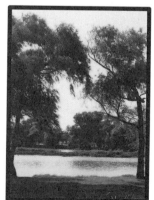

| Sunrise | Early morning | Noon | Late afternoon |

Time of Day High vs Low Angle of Light

■ Direct Light

Harder to Work With at Noon:

The high angle of light causes bad shadows. Light rays travel the shortest distance and are the harshest at noon. Generally, direct light at noon has a high light ratio. In the morning or afternoon the lower angle of light creates better shadows and is less harsh. Light ratios can still be high in direct light.

Direct light at noon
Bad shadows and harsh light ratio

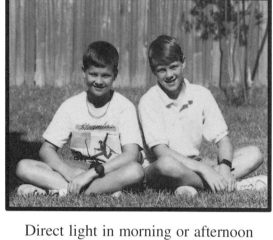

Direct light in morning or afternoon
Better shadows and light ratio

■ Backlight

Less Area to Work In at Noon:

The high angle of light at noon causes loss of detail on the top of the subject with backlighting.
With backlighting in early morning or late afternoon the lights' angle is lower. There is a rim of light around the subject instead of loss of detail on top of it.

Backlight at noon
Loss of detail on top of subject

Backlight in morning or afternoon
More detail on top of subject

Time of Day
High vs Low
Angle of Light

◼ Diffused Light

Deeper Shadows at Noon:

The high angle of light at noon creates deeper shadows on the subject than the lower angle of light in the morning or afternoon.

Diffused light at noon
Creates bad shadows on subject

Diffused Light in morning or afternoon
Creates better shadows on subject

◼ Shaded Areas

Less Area to Work In at Noon:

The higher the sun, the fewer shaded areas it creates to shoot in. There are also fewer shaded background areas you can use. The lower angle of light in the morning and afternoon creates more shaded areas and shaded background areas to work in.

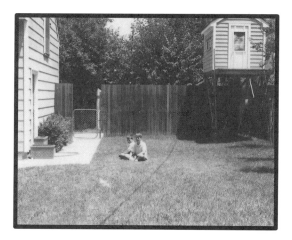

Shaded areas at noon
Less shaded areas to work in

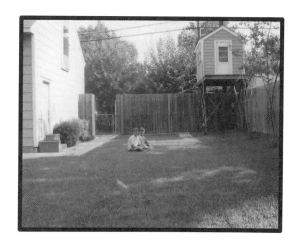

Shaded areas in morning or afternoon
More shaded areas to work in

49

Lens Flare

■ Use Lens Shade or Stand in Shade

Sunlight on Lens:

Lens flare can be caused by the angle the sunlight hits the lens. This usually happens when shooting toward the sun early or late in the day when the sun is low. You can use a lens shade, change your camera angle, shoot from a shaded area or in the shadow of an object like a tree.

Sunlight into lens causing flare

Sunlight blocked from lens

Timing Sunrise and Sunset

■ Before, During & After

Three Choices:

The light is a little softer ten minutes before sunrise than right at sunrise and can get harsher within ten minutes after. The light at sunset is harsher ten minutes before sunset, softer at sunset, and even softer right after. The time of year affects how long it lasts. Clouds can affect both sunrise and sunset. Backlight is one option when the light is too harsh.

Just before sunrise

Right at sunrise

Just after sunrise

Time of Day

■ Summary

Light Angle and Shadows:

Try to see how the angle of the light changes from low to high and the shadows it makes at different times of day.

Early Morning and Late Afternoon:

See how the angle of light is lower creating better shadows on the subject. There are more shaded areas to work in for the subject and backgrounds.

Noon:

See how the angle of light is higher and the light and shadows are harsher on the subject. There are fewer shaded areas to work in for the subject and backgrounds.

Direct or Backlight:

If the front of a building is in direct light in the morning, it will be in backlight in the afternoon and vice versa.

Improve Your Skills

1. Person at sunrise
2. Person in early morning
3. Person at mid morning
4. Person at noon
5. Person in early afternoon
6. Person in late afternoon
7. Person at sunset

8. Scene at sunrise
9. Scene in early morning
10. Scene at mid morning
11. Scene at noon
12. Scene in early afternoon
13. Scene in late afternoon
14. Scene at sunset

Mini Quiz

1. The angle of light is _____ early and late in the day for a better angle of light and more shaded areas to work in.

2. At _____ the angle of light is high, shadows are bad on faces and there are fewer shaded areas to work in.

3. Sunrise and sunset have both a good angle of _____ and the longer rays of light are softened by the atmosphere for a good lighting ratio.

4. The _____ of year can affect how long sunrises and sunsets last.

5. You can plan a photograph knowing what the light will be at a certain time of ___ .

(1. lower 2. noon 3. light 4. time 5. day)

Lighting Ratio

The difference between the amount of light in the shadow and light areas of your photograph

What your eyes see and what film and paper can record are two *different* things. This is especially true when there is a big difference in the amounts of light in different areas of a photograph.

If there is three times as much light in the light area as the shadow area, the lighting ratio is three to one. This is a *low* ratio and film can handle it.

If there is 10 times as much light in the light areas as shadow areas the lighting ratio is 10 to one. This is a *high* ratio and film can't handle it. You will lose detail with the shadow areas going black or the highlight areas going white. When the light areas and shadow areas have close to the same amount of light on them, it's no problem. When there is an *extreme* difference between the amount of light in the light and shadow areas, there is a problem.

Your eyes may see *detail* in those areas, but film can't record detail in both extremes at the same time.

Film and photographic paper record light by a *mechanical* process and can't record the extreme lighting ratios like your eyes can. An old trick is to squint your eyes and look through your eyelashes at a scene. This can let you see how the detail will disappear in the highlight and shadow areas. You can have a high ratio on the subject throughout a scene or between the subject and the background.

Flash, reflectors and light blocks are one way to help *even* the lighting ratio. You can use a backlight button or spot meter to help set your exposure for the subject and not the background.

Subject Light Ratio

■ Low Lighting Ratio

Small Difference in Amounts of Light:

The difference between the amount of light on the light and shadow areas of the subject is the light ratio. In a low light ratio, the difference between the two is small. You can have up to three times as much light in the light areas as in the shadows, and the film will record detail in both areas.

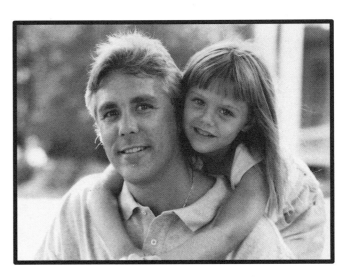

Subject: *Low lighting ratio*
Small difference between amount of light in light and shadow areas

■ High Lighting Ratio

Big Difference in Amounts of Light:

A high lighting ratio has a big difference between the amount of light in the light and shadow areas of the subject. If there is more than four times the amount of light on the light areas than in the shadow or shaded areas, the film can't record detail on both areas at the same time.

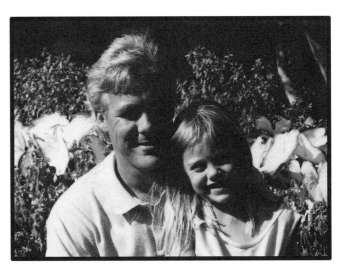

Subject: *High lighting ratio*
Big difference between amount of light in light and shadow areas

Subject to Background Light Ratio

■ Low Lighting Ratio

Small Difference in Amounts of Light:

There is a small difference between the amount of light on the subject and the background. There can be up to three times as much light on the subject as on the background, and the film will record detail in both.

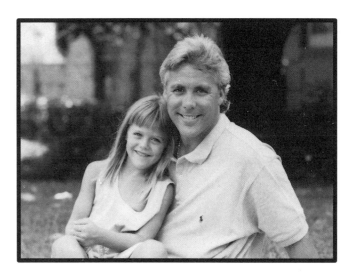

Subject to Background: *Low lighting ratio*
Small difference between amount of light on subject and background

■ High Lighting Ratio

Big Difference in Amounts of Light:

There is a big difference between amount of light on the subject and background. The subject is in shade, and the background is in direct sunlight. If there is more than four times the amount of light on the subject than on the background, the film can't record detail in both areas at once.

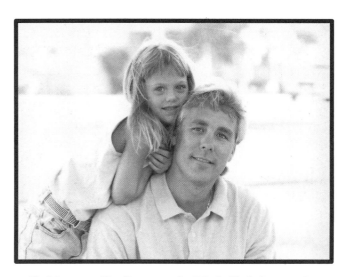

Subject to Background: *High lighting ratio*
Big difference between amount of light on subject and background

55

Subject in Shade or Backlight with Bright Background

■ High Lighting Ratio

Set Meter for Subject or Background:

If you set the camera for the subject, the background will be very bright. If you set the camera for the background, the subject will be very dark.

Camera set for amount of light on background

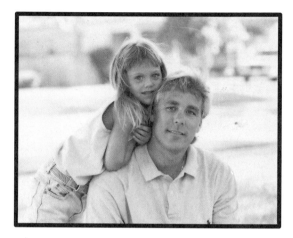

Camera set for amount of light on subject

■ Setting Your Camera

Backlight Button:

The backlight button adjusts the cameras light meter for the subject not the bright background automatically.

Spot Meter:

A camera's spot meter reads a tiny area and can measure the light on only the subject.

Moving in for Lightmeter Reading:

Move in to fill the frame with the subject for the light meter reading and then back up to shoot.

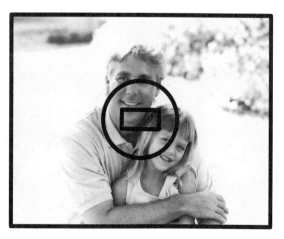

Spot meter reads light from small area to meter subject area and not background

Move in to fill frame with subject to take meter reading

Working With High Lighting Ratios

■ Harsh Shadows

Direct Sunlight and Harsh Shadows:

Direct sunlight can create harsh shadows on the subject with no detail in them.

■ Fill Flash

Flash to Fill in Harsh Shadows:

A flash can add light to the shadow areas. This lightens the shadows so you can see detail in them and lowers the ratio.

■ Backlight

Backlight for Soft, Indirect Light:

Changing the camera angle so the sun is behind the subject will create backlight and shade on the front of the subject for even light.

■ Light Block

Light Block for Indirect Light:

A light block can block the direct light to create shade and more even light on the subject.

Direct sunlight with harsh shadows

Flash to fill in shadows

Change camera angle
for backlighting

Using a light block
to create shade

Backlighting and Flash

■ Lighting Tool

Helps Balance Light Ratio:

Using flash on a backlighted subject puts more light on it. This helps balance the amount of light between the subject and the background.

Subject is backlighted
Background is in bright sunlight

Flash on the subject, evens the light level with the subject and the bright background

Harsh vs. Soft Light

■ Shadow Edges

Direct vs. Indirect Light:

The shadows from direct sunlight have harsh edges and little detail. The shadows created by window light have softer edges, lower angle of light and better detail.

Direct sunlight is harsher
with high lighting ratio

Indirect window light is softer
with high lighting ratio

Lighting Ratio

■ Summary

Identify Low and High Light

Find a low and a high lighting ratio situation.

Subject:

Photograph subject in a low and a high lighting ratio. Try using lighting tools to help even the ratio.

Subject to Background:

Photograph the subject in a low and high lighting ratio with the background. Try using different lighting tools to work with the ratio.

Metering for the Subject:

Set the camera for the amount of light on the subject for detail in the subject. Set the camera for the light on the background for a sillouette of the subject.

Improve Your Skills

Subject Light Ratio

1. Shoot subject with harsh light ratio

2. Use flash to even light ratio

3. Use reflector to even light ratio

4. Use light block to even light ratio

5. Change camera angle for backlighting

6. Photograph subject in window light

Subject to Background Light Ratio

7. Shoot harsh subject to background ratio

8. Use reflector to even light ratio

9. Use flash to even light ratio

10. Set camera meter for light on background

11. Adjust camera meter for light on subject

12. Change camera angle to get background in shade

Mini Quiz

1. Your eyes can see detail in a wider range of light and shadows than _____ can record.

2. Direct sunlight generally has a _____ lighting ratio that loses detail in highlight and shadow areas.

3. A three to one _____ ratio means there is three times as much light on the light areas as in the shadow areas of the subject.

4. A three to one lighting ratio is generally the highest ratio that film can record detail in both light and _____ areas at the same time.

5. Using backlighting, shade, flash or a light block will help even out the lighting _____.

(1. film 2. high 3. lighting 4. shadow 5. ratio)

59

Lighting Tools

Natural and man-made tools to control and direct the light

Use the lighting tools around you to *change* the direction and ratio of light.

Use shade by placing your subject in it to shoot.

If there is no shade, change your *camera position* so the sun is behind your subject and you have backlighting. With backlighting, the subject creates its own shade. You also get a rim of light around the subject.

If the shade isn't solid, light through *tree leaves*, etc., you may want to use a flash or backlighting.

Find an overhang like a porch, tree, awning, etc. and place your subject under it. It will *redirect* the light to a lower angle for you. Watch as the quality of light changes the further under the overhang you put your subject.

A white wall or building, snow or sand can be a *natural* or existing reflector to reflect light on your subject.

You can use pieces of cardboard to create shade, an overhang or to reflect light.

The *angle* of a reflector in direct sunlight controls the amount of light more than its distance from the subject.

The reflectors *distance* from the subject in the shade controls the amount of light more than the angle to the subject.

A light block is sort of a reflector that *subtracts* light and creates shadows.

A flash can be used to add light to the subject to change the direction and ratio of the light.

Using Shade

■ Put Subject in Shade

Move Subject or Come Back Later:

Move the subject into the shade. If the subject isn't moveable, you may want to take a shot and then come back later to try again when it is in the shade.

Notice the difference between the subject and background is less when both are in shade than when one is in bright sunlight and the other is in shade.

Subject in sunlight

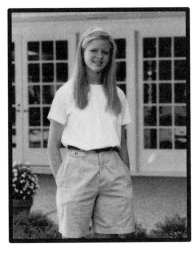

Subject moved into shade

Backlight to Create Shade

■ Subject Blocks Direct Sunlight

Standing in Its Own Shade:

You can create shade anywhere with backlighting. Putting the sun behind the subject creates shade on the front of the subject.

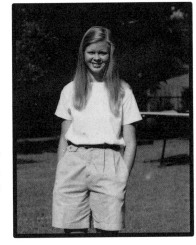

Direct sunlight on subject

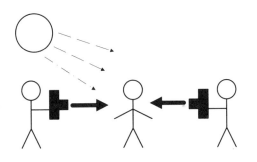

(Subject is turned to face camera)

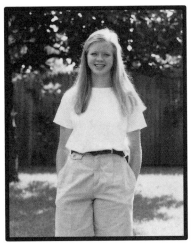

Direct sunlight on back of subject, shading the front

Working in Filtered Shade

■ Sunlight Through Tree Leaves

Spotted Light:

Shade created by leaves, etc., isn't always solid and can cause distracting bright spots of light. It will look better to your eyes than on the photo you get back. Backlighting or flash can even out the light.

Filtered Shade

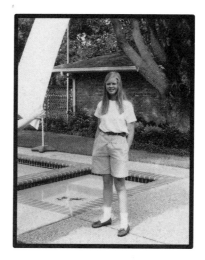

Filtered shade with flash

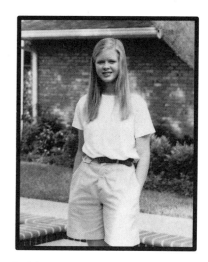

Change camera angle to get backlighting

Using a Light Block

■ Creating Shade

Blocking Sunlight:

A piece of cardboard can be used to block sunlight from the subject and create shade. Any object can be used to block the light.

Notice how changing the amount of light on the subject changes its light ratio to the background.

Direct sunlight / No light block

Holding light block

Subject shaded by light block

Overhang Lowers Angle of Light

◢ Redirecting the Light

Changing the Light's Direction:

An overhang makes the light come under it at a lower angle. This creates good lighting at a better angle for the subject.

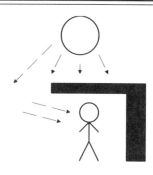

Subject in direct sunlight with a high angle of light

Placing the subject under overhang redirects the light to a lower angle

Finding Overhangs

■ Look Around You

On Location:

When you are photographing, look for doorways, windows, awnings, porches, entry ways, trees, etc. that can be used as overhangs to redirect the light to a lower angle.

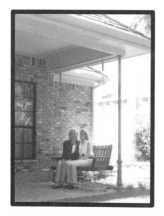

Porch or awning Window or doorway Tree or nature Create an overhang using cardboard

How High
is Overhang?

■ Changes Light Angle

Higher or Lower Lighting Angle:

How high is the overhang above the subject? The higher the overhang the higher the angle of light.

High overhang
Higher angle of light

Low overhang
Lower angle of light

How Far Under
is Subject?

■ Changes Light Angle

Higher or Lower Lighting Angle:

How far under the overhang the subject is, changes the angle of light on it.

Quality and Amount of Light:

The quality and amount of light will change, the farther the subject is under the overhang. See where the light looks best.

Subject at edge of overhang
Higher angle of light

Subject farther under overhang
Lower angle of light, less light

Reflector
in Sunlight

■ Angle and Distance

Reflector Angle:

Reflecting direct sunlight, the reflector's angle controls the amount of light it reflects.

Reflector Distance:

The reflector's distance from the subject doesn't matter as much in direct sunlight.

Without reflector in direct light

Holding reflector

Reflector adds light to subject
(Direct light at noon is harsh)

Reflector
in Shade

■ Distance and Angle

Reflector Distance:

In the shade, the reflector's distance from the subject controls the amount of light it reflects. Move the reflector in and out to see where the light looks best.

Reflector Angle:

The reflector's angle in shade will affect the light, so turn it to see what angle looks best.

Without Reflector in shade

Holding reflector

With reflector in shade

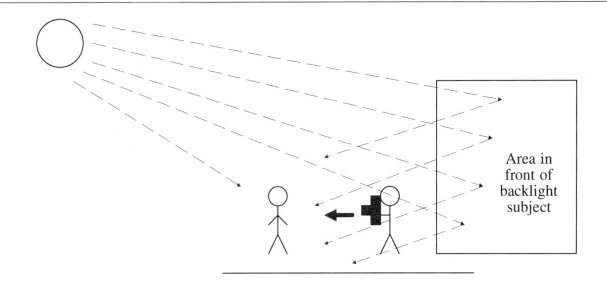

Backlighting and Reflected Light

■ Like A Giant Reflector

Light Bounces Off Area in Front:

When the sun is behind the subject whatever is in front of the subject reflects sunlight back into the subject.

The area in front of the subject could be an open field, a building, or whatever. The whole area reflects light back onto the subject to create soft lighting.

Area in front of backlight subject

Black Reflector

■ Subtracts Light

Creating Shadow on Subject:

Blocking light from one side creates shadow on that side of the subject. Instead of adding light, it subtracts it creating a shadow that adds shape to the subject.

(A reflector can also be used to block light and create shade.)

Holding light block

Light block creates shadow

Tree trunk blocks light to create shadow

Lighting Boards

■ Three Basic Boards

Board Surfaces:

A board can be made of plain cardboard, foam core or corrugated plastic. You can use tape for hinges. Boards can be used for a variety of subjects like people, flowers, food, etc.

■ Telephoto Lens

Don't Show Light Tools:

A telephoto's narrow view makes it easier to show just the subject and crop out the light tool.

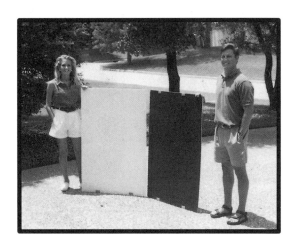

White and black sides of boards
(Smaller boards can be used for smaller subjects)

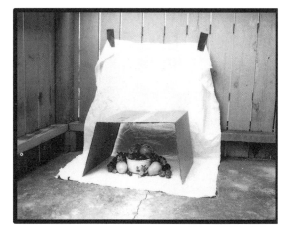

A cardboard box and draped material for a background with a bowl of fruit

One Lighting Board

■ Three Choices

Light Block, Overhang, Reflector:

Use one board to control the light as a light block, an overhang or a reflector.

Light block

Overhang

Reflector

Two Lighting Boards

■ Three Combinations

Use Two Boards to Control Light:

Combine two boards to control the light, a light block and overhang, a light block and reflector, or an overhang and reflector.

Light block and overhang

Light block and reflector

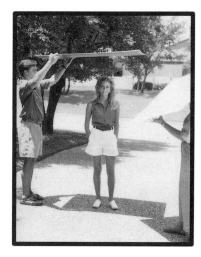

Overhang and reflector

Three Lighting Boards

■ Many Combinations

Use Three Boards to Control Light:

Combine three boards to create a window with an overhang and two light blocks on each side. Use white or black inside. Have fun experimenting with light boards on people, flowers and other subjects.

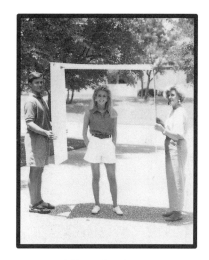

All white inside
three sided box

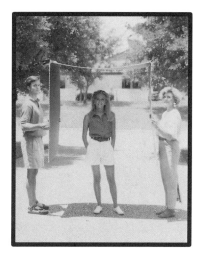

All black inside
three sided box

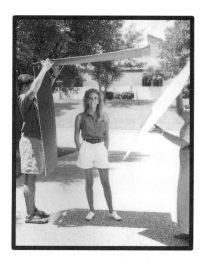

Overhang, light block
and reflector

Flash as Main Light

■ Adds Light to Subject

Not Enough Existing Light:

A flash can be used to add light to the subject when there isn't enough light to take a photograph.

Not enough light to take photograph

Flash provides light to take photograph

Flash as Fill Light

■ Sunny Day

Harsh Light at Bad Angle:

When the sun's angle is too high it creates dark, harsh shadows on the face. Using a flash adds light at a lower angle and helps fill in the shadows for more even lighting.

Harsh shadows and light ratio

Flash fills in shadows and softens light ratio

Flash as Fill Light

■ Cloudy Day

Soft Light at Bad Angle:

When the light is coming from a bad direction or angle, it can create bad shadows. The flash fills in the bad shadows by adding light at a lower angle.

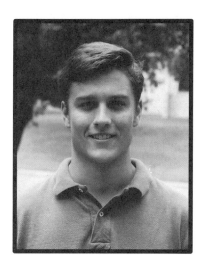

Shadows created by high angle of light

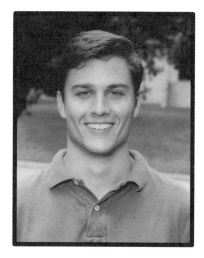

Flash creates lower angle of light

Flash to Stop Action

■ Burst of Light

Stopping Action:

Using a flash can stop action. If there is a lot of existing light, you might get a blurred or ghost image from the available light along with the flash image. Notice the blur on top of the volleyball in the second photograph. Be careful of camera movement when shooting in bright light areas as it can blur the natural light image also.

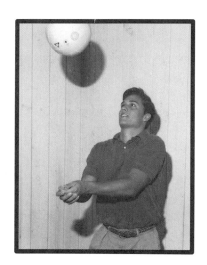

Flash stops action

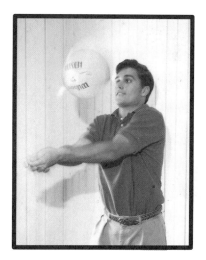

Flash image with ghost image from existing light

71

Lighting Tools

■ Natural Surroundings

Control Light Using What's There:

Look around your surroundings to find light tools you can use. You can move your subject into the shade or change your angle to backlight your subject creating its' own shade. Overhangs like trees, porches, doorways, awnings, etc. can be used to control the angle of the light. Sidewalks, buildings, sand, fields, etc. reflect light and can affect your lighting.

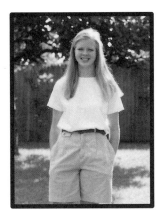
Using camera angle to create backlighting

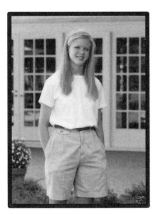
Using shade from surroundings

Using an overhang from surroundings

Using reflectors from surroundings

■ Portable Light Control

Redirecting the Light:

A flash can fill in the shadows and lower the angle of light. You can use a light board to block the light and create shade, make an overhang or reflect light. They are portable which usually limits their size.

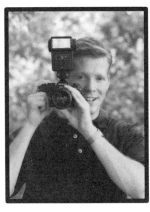
Using portable flash

Using portable shade

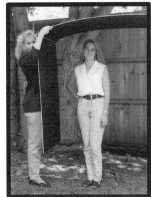
Using portable overhang

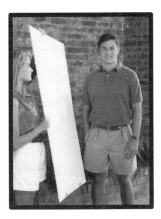
Using portable reflector

Lighting Tools

■ Summary

Shade:

Place your subject in shade or use a light block to create shade for it.

Overhang:

Place your subject under an overhang or create one for it with a piece of cardboard.

Reflector:

Use natural reflectors like sand and snow or a reflector to reflect the light.

Lighting Boards:

Use natural reflectors like sand and snow or a manmade reflector to reflect the light.

Flash:

Use a flash to add light to your subject when there isn't enough light to take a photograph or to fill in shadows.

Improve Your Skills

1. Place subject in direct sunlight
2. Place subject in backlight
3. Place subject in shade
4. Place subject under an overhang
5. Use flash
5. Use time of day (sunset)
7. Use white reflector to add light
8. Use black reflector to subtract light
9. Use light board to block light & create shade
10. Use light board to create an overhang
11. Use two light boards
12. Use three light boards

Mini Quiz

1. Placing the subject in _____ creates indirect light which is less harsh than direct sunlight.

2. _____ puts the subject in its own shade.

3. An _____ redirects the light to a lower angle.

4. A _____ reflector adds light to the subject, a black reflector subtracts light and creates shadows.

5. Using a _____ can fill in shadows.

(1. shade 2. Backlighting 3. overhang 4. white 5. flash)

Flash

Add light to the subject with flash

A flash can provide the *main* light for your subject when there is not enough light to shoot without it.

A flash can provide *fill* light when there is enough light to shoot, but the shadows are bad. The flash fills in the shadows and gives good direction to the light.

You can use flash outdoors at sunset with backlighting to capture the sunset with good light on the subject.

Cameras with a built-in flash aren't as *powerful* as some people think. They shoot from the top of a stadium at the field 200 yards away, when the flash's maximum distance is probably about 12 to 20 feet depending on your film speed.

The minimum distance for a camera with built-in flash is *usually* four feet from the subject with 100 speed film.

Higher speed films need less light so the maximum flash distance is farther. The minimum distance to the subject increases with higher film speeds, too.

Flashes need time to *recharge* between shots, usually from six to 12 seconds. A ready light on the flash or camera back or in the camera viewfinder says when it's charged. When in close, the flash uses less power and recycles faster.

You need *two inches* between the lens and flash for every *five feet* from your subject to prevent red eye. Cameras with built in flash that have the longest distance between the two work the best. If your camera is bad about red eye, you can try shooting closer, buy a separate flash for it, or buy a new camera with more distance *between* the flash and lens.

Main Light or Fill Light

■ Flash Indoors

Flash as Main Light Indoors:

When indoors without enough light to take a photograph, the flash provides the main light needed.

Flash as Fill Light Indoors:

If there is enough light to shoot indoors, using a flash provides fill light.

Flash as main light indoors

Flash as fill light indoors

■ Flash Outdoors

Flash as Main Light Outdoors:

When outdoors and without enough light to take a photograph, the flash provides the main light needed.

Flash as Fill Light Outdoors:

If there is enough light to shoot outdoors, using a flash provides fill light.

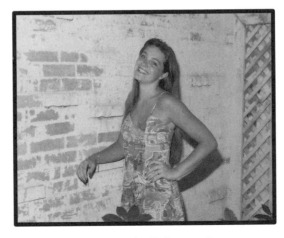

Flash as main light outdoors

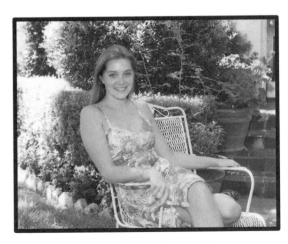

Flash as fill light outdoors

Maximum and Minimum Flash Distances

■ Your Flash's Power

Cameras with Built-in Flash:

Most cameras with built-in flash have a maximum distance of 12 feet and a minimum distance of four feet with 200 speed film. Check your camera's manual.

Independent Flashes:

Independent flashes have dials that show their working distance for the film's speed.

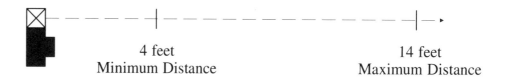

4 feet	14 feet
Minimum Distance	Maximum Distance

Average minimum and maximum flash distances with point-and-shoot camera and 200 speed film

Flash Recharge Times

■ Full Charge Needed

Six to Twelve Seconds:

A flash needs six to twelve seconds to recharge between shots. The flash ready light in the viewer or camera back will light up when it's ready to shoot. At closer distances, the flash uses less power and may recycle faster.

6 to 12 Seconds

Flash
Recharge
Time

See if the camera's flash ready light is on

What Causes Red Eye?

■ Flash too Close to Lens Causes Red Eye

Narrow Angle of Reflection:
When the flash is located too close to the lens, it reflects off the eyes, almost straight back into the lens. This reflects the blood vessels in the eye and looks red.

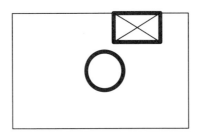

Flash too close to lens

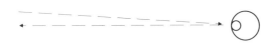

Narrow angle of reflection

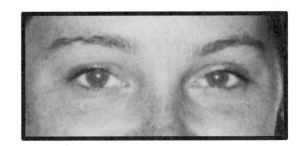

Red eye reflected
Pupil lighter and red

■ Flash Further From Lens Prevents Red Eye

Wider Angle of Reflection:
When the flash is located further from the lens, the angle the flash reflects back into the lens is wider and prevents red eye.

Flash located further from lens

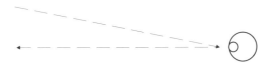

Wider angle of reflection

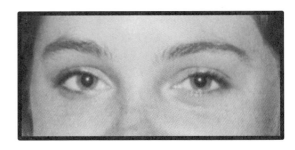

No red eye reflected
Pupil normal and not red

How to Prevent Red Eye

◼ Locating Flash Further From Lens

Flash to Lens Distance:

If you are buying a camera, look for one with the most distance between the flash and lens. If you can add an independent flash, it will add more distance between the flash and the lens.

Flash located far from lens

Pop-up flash

Flip-up flash

◼ Two Inches For Every Five Feet

Basic Rule of Thumb:

You need two inches between the flash and the lens for every five feet you are from the subject.

Something to Try:

If your camera is bad at red eye, you might try shooting at closer distances to see if it helps. Some cameras with built-in flash are hopeless when it comes to red eye.

Flash on top of camera with hot shoe

Flash on bracket attatched to camera

79

Film Speed and Flash Distance

■ Higher Speed Longer Distance

Maximum Distance Increases:

The higher the speed film, the less light it needs, so it records the light from the flash at farther distances.

Minimum Flash Distance:

The higher film speed will increase the minimum distance you need to be from your subject with most built-in flash cameras.

Combining Flash and Natural Light

■ Different Light Levels

Balancing Flash and Natural Light:

More room light helps keep the background from going black behind the subject. The distance between the flash, subject and background will make a difference. Using a higher speed film will capture more natural light. A camera setting close to natural light level also works.

Sample: Maximum Flash Distances with Different Film Speeds

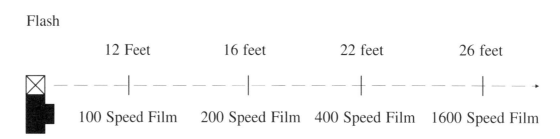

Flash

12 Feet	16 feet	22 feet	26 feet
100 Speed Film	200 Speed Film	400 Speed Film	1600 Speed Film

Room light without flash

Combining room light with flash on subject

Flash

■ Summary

Main Light:

Use your flash as the main source of light when there isn't enough light to take a photograph.

Fill Light:

Use your flash to fill in the shadows when there is enough light to shoot, but the shadows are harsh, or the angle of light is too high.

Red Eye:

Try to have two inches between the flash and your camera's lens for every five feet you are from your subject. A separate flash on your camera can help with this.

Recharge Time and Flash Distance:

Look at your manual to see what the recharge time and maximum and minimum distances are for your flash.
My flashes:
Maximum Flash Distance___feet
Minimum Flash Distance___feet

Improve Your Skills

1. Low light indoors without flash
2. Low light indoors with flash
3. Without flash outdoors
4. With flash outdoors
5. Closer than minimum distance
6. Further than maximum distance
7. Within flash's range
8. Flash to stop action in dark area
9. Flash to stop action in light area
10. Flash to fill in shadows in direct sunlight
11. Flash to fill in shadows in shade
12. Flash with backlight

Mini Quiz

1. A flash can be the main light to provide _____ when there is not enough light to take a picture.

2. Flash can be a fill light to add light and ____ in shadow areas.

3. Flash can be used to stop_____ but can get a ghost image in bright light from the moving subject or camera movement.

4. Red eye is caused by the flash being too _____ to the lens.

5. Minimum flash distance from a subject is generally three to ____ feet.

(1. light 2. fill 3. action 4. close 5. four)

81

Lens

Wide-angle and telephoto lens give different views of the subject

A wide-angle lens pushes the subject away, a telephoto lens brings the subject closer and a normal lens gives a normal view.

Most people just stand where they are and shoot. If they have a zoom lens, they will zoom it to cover the area and shoot, not caring if the setting is wide-angle or telephoto.

Just as with the walk-around angle, you have to *walk a little* to see how something looks. You may have to move back some to see the same view with the telephoto as you did with the wide-angle lens.

If you have a wide angle and telephoto lens or a zoom lens, look at the subject with the wide angle and the telephoto. If you have to move a little to get the view you need, do it.

You *don't* look through the lens with a viewfinder camera. What you see and what the lens sees can be two different things. Cropping into people's heads and camera straps or fingers in front of the lens are some of the problems.

The *normal view* you see through the viewfinder is different than what the wide angle lens sees. The wide-angle lens pushes the subject away. That is why the subject didn't look so far away when you took it, but does in the print you get back.

Most viewfinder cameras use a wide-angle lens. It covers big areas and has a deep depth of focus.

Basic Lens in Millimeters

Ultra Wide Angle Lens:

14 mm, 16 mm, 18 mm, 20mm
(*Distortion & Non-distortion*)

Wide Angle Lens:

24mm, 28mm, 35mm

Normal Lens:

50mm, 55mm

Telephoto Lens:

80mm, 105mm, 135mm, 200mm

Long Telephoto Lens:

300mm, 500mm, 1000mm

Wide-angle Lens

■ Shows More Area with Wide View

Wide Coverage:

A wide-angle lens pushes the subject away showing more area and a wider view.

Wide-angle lens pushes subject away

Wide-angle lens shows more area

Telephoto Lens

■ Shows Less Area with Narrow View

Narrow Coverage:

A telephoto lens brings the subject closer showing less area and a narrower view.

Telephoto lens brings subject closer

Telephoto lens shows less area

Wide-angle Lens

■ Shorter Distance and More Background

Shorter Working Distance:

A wide-angle lens has a shorter working distance from the subject.

Shows More Background:

A wide-angle lens pushes the background away and shows more background behind the subject.

Wide-angle lens shows more background behind the subject

Wide-angle lens has a shorter working distance

Telephoto Lens

■ Longer Distance and Less Background

Longer Working Distance

A telephoto lens has a longer working distance from the subject.

Shows Less Background:

A telephoto lens brings the background closer and shows less background behind the subject .

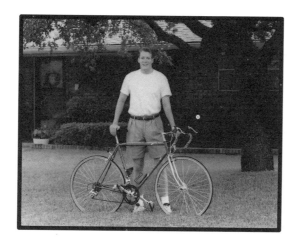

Telephoto lens shows less background behind the subject

Telephoto lens has a longer working distance

Wide-angle Lens

■ Expands the Scene for a Looser Look

Objects Look Further Apart:

A wide-angle lens expands the scene making objects in front and behind the subject look further apart.

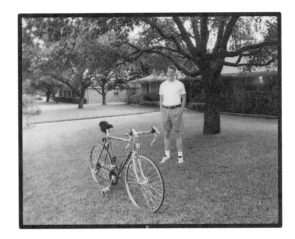

Wide-angle lens makes
objects look further apart

Wide-angle lens expands
the scene

Telephoto Lens

■ Compresses the Scene for a Tighter Look

Objects Look Closer Together:

A telephoto lens compresses the scene to make objects in front and back of the subject look closer together.

(Subject stayed in same position for both photographs. Notice the size of the front wheel is the same in both photographs.)

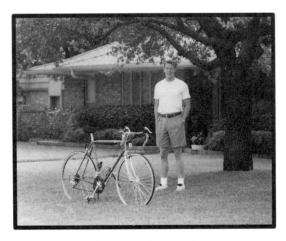

Telephoto lens makes
objects look closer together

Telephoto lens compresses
the scene

Background Focus and Nearness

■ Wide-angle - Telephoto

Wide-angle Lens:

A wide-angle lens pushes the background and subject away and has the background in sharper focus.

Telephoto Lens:

A telephoto lens brings the subject and background closer and blurs the background more.

Depth of Focus

■ Size of Lens Opening

Opening Size Changes Focus Depth:

Changing the size of the opening in the lens that the light comes through will change the depth of the focus and blur or sharpen the background. Notice the leaves blur and try reading the sign in the background. The smaller the opening, the more focused the light and the deeper the focus in front and behind the subject.

The size of this adjustable opening also controls the amount of light to the film.

(Fashion photographers will choose a background far behind the model to help blur it.)

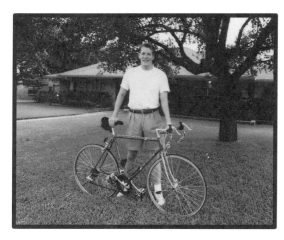

Wide-angle lens pushes away
(Background is in sharper focus)

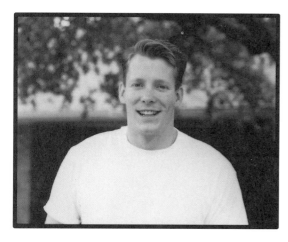

Telephoto lens brings closer
(Background is more blurred)

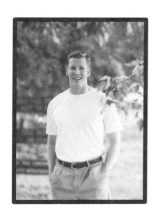 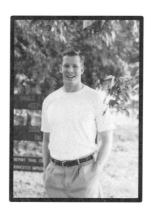 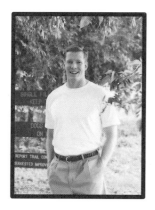 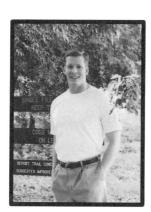

| *f* 2.8 | *f* 4 | *f* 5.6 | *f* 8 |

87

Normal Lens

■ Normal View

Like You Normally See:

A normal lens has close to the same coverage and perspective as you see with your eyes. It is usually a 50mm or 55mm lens. Its view is between a wide angle and telephoto lens.

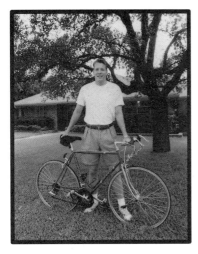

Wide-angle lens

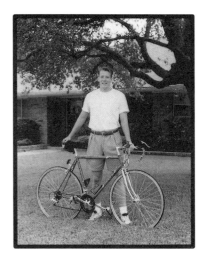

Normal lens

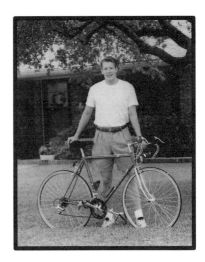

Telephoto lens

Macro Lens

■ Extreme Closeups

Making Little Things Big:

A macro lens barrel extends the lens to magnify the subject and allow you to take extreme close-ups. You can also take regular photographs with a macro lens. Standard and zoom lenses can be bought with macro capabilities.

Macro lens photograph

Macro lens photograph

Macro lens photograph

Zoom Lens

■ Wide-angle - Telephoto Walk Don't Zoom

Zoom to get lens you want to use:

A zoom lens lets you go from wide angle to telephoto without changing the lens. Walk to change your distance from the subject for your lens choice and image size.

Trade off in Light Lost:

A zoom lens lets in less light than a standard lens. The amount of light lost can be the difference between 100 and 400 speed film. Zooms also don't focus as close.

Holding Your Camera

■ Camera Movement

Body and Lens:

You can hold a viewfinder camera body with your hands. With a camera that allows you to add longer lenses, you may want to hold the camera body with one hand and support the lens with the other. You can focus and then leave your hand on the focus ring to hold the lens.

WALK don't Zoom

(Choose your lens for the look you want and walk to get the view you need.)

Zoom set at wide-angle

Zoom set at telephoto

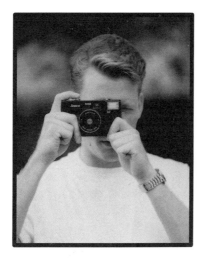

Holding viewfinder body

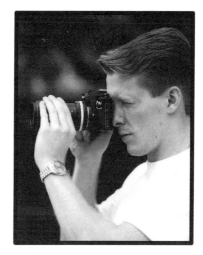

Holding camera body and lens

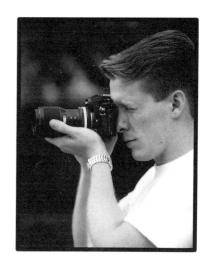

Holding camera body and lens

Portrait

■ Four Reasons to Use a Telephoto Lens

1. Working Distance:

A telephoto lens lets you have a comfortable working distance with your subject instead of being right in their face.

2. Less Background to Distract:

A telephoto lens shows less background behind the subject so there are fewer distractions, and more attention is on the subject.

3. Less Depth of Focus:

A telephoto lens has less depth of focus so the background is more blurred and less distracting.

4. Compresses Subject:

A telephoto compresses the subject's face, which looks better than with the wide-angle, which expands the face.

(Same subject in both photos)

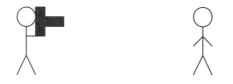

Telephoto lens has
longer working distance

Wide-angle lens has
shorter working distance

Telephoto lens compresses subject
Shows less background

Wide-angle expands subject
Shows more background

Filters

■ Filter Choices

Many Filters Available:

A filter in front of your lens can change your photograph. There are many filters available. You can write to filter manufacturers for their catalogs that list filters, their effect and how to use them.

Wide-angle and Telephoto Lens

■ Short and Long Lens

Toilet Paper Roll Experiment:

Take the cardboard center from a roll of toilet paper and cut a one inch section and a three inch section. Look through them to see a wide angle view with the shorter piece and a telephoto view with the longer piece.

Framing With Your Hands:

You can make a frame with your hands to frame the subject like you see Hollywood directors do. Holding your hands further away will give a telephoto view and closer will give a wide-angle view.

Skylight Filter
Protects the lens
and filters UV

Diffusion Filter
Softens subject

Polarizing Filter
Reduces reflections and
deepens sky, grass & leaves

A one inch and three inch
roll of cardboard

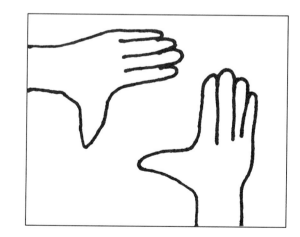

Holding hands to frame subject

91

Try to Photograph Subject Two Ways

Same distance / Different views

■ Same Distance Different Views

Wide-angle and Telephoto:

Photographing the subject from the *same distance* with a wide-angle lens and a telephoto lens will give two *different views* of the subject.

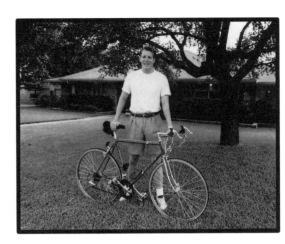

Wide-angle Lens

Telephoto Lens

■ Same View Different Distances

Same view/ Different distances

Wide-angle and Telephoto:

To get the *same view* of the subject, you will need to be at *different distances* with a wide angle and telephoto lens. Standing closer with the wide angle and further away with the telephoto will give the same view but two different looks to the subject.

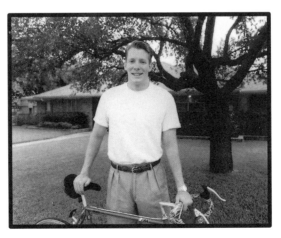

Wide-angle Lens

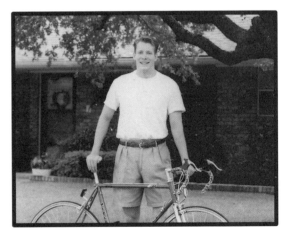

Telephoto Lens

Lens

■ Summary

Distance and View:

Try photographing your subject with a wide-angle and a telephoto lens from the same distance with different views and the same view from different distances. Try it with a normal lens too.

Zoom Lens:

Don't use a zoom lens just so you don't have to walk a couple of steps. Zoom it to wide-angle for a wide-angle look or telephoto for a telephoto look.

Filters:

Try using filters to give different looks to your photographs.

Lens Shade:

Use a lens shade on lenses longer then 50mm to avoid flare in the lens.

Improve Your Skills

Scene

1. Use wide-angle lens at same distance
2. Use normal lens at same distance
3. Use telephoto lens at same distance
4. Use wide-angle lens with same subject size
5. Use normal lens with same subject size
6. Use telephoto lens with same subject size.

Person

7. Use wide-angle lens at same distance
8. Use normal lens at same distance
9. Use telephoto lens at same distance
10. Use wide-angle lens with same subject size
11. Use normal lens with same subject size
12. Use telephoto lens with same subject size.

Mini Quiz

1. A _____ angle lens expands the scene and pushes the subject and background away.

2. A _____ lens compresses the scene and brings the subject and background closer.

3. For portraits of people a _____ lens is best.

4. A _____ filter gives a soft look to a photograph.

5. Using a lens _____ can help you avoid flare in your lens.

(1. wide 2. telephoto 3. telephoto 4. diffusion 5. shade)

93

C.A.L.L.

Do you have the best...

Composition

Angle

Lighting

Lens

■ Easy to be Creative

Easy to remember:

C.A.L.L. is a quick easy checklist to get your creativity flowing. It helps you think of different combinations of the basics which can lead to other creative thoughts and ideas.

C.A.L.L.
Creativity Checklist

Composition: Crop by thirds, place on thirds

Angle: Walkaround and low, normal, high

Lighting: Four types, ratio and tools

Lens: Wide angle, normal, telephoto

■ Creative Reminder

Easy to Forget:

You can get so busy while photographing you can forget your options. C.A.L.L. is a good way to quickly review and refresh your creative mind while photographing.

Film

Match film sensitivity to amount of light you have

Like different size bowls needing different *amounts* of water to fill them, different film speeds need different amounts of light to fill them.

A film's sensitivity to light is *rated* by its speed. The higher the film speed, the more sensitive it is to light .

A lower film speed needs more light. A higher film speed needs less light.

Try to *match* the amount of light the film needs with the amount of light you are working in. In sunlight you can use a low speed film that needs a lot of light. Indoors you need a high speed film that doesn't need much light if you aren't using a flash.

The higher the film speed, the larger the light sensitive silver grains in the film. You get less detail with large grain in big enlargements.

If a woman was trying to find an outfit to work in the yard, play tennis, go to lunch and then to a black tie party, it would be hard to find one outfit to do it all.

You can't ask for one film speed to cover *every* lighting situation and do it well. Find the best average film speed for what you need. You may need to buy a roll of a film with a different film speed to cover a special lighting situation and event.

Use negative film if you want prints and slide film if you want slides. Getting prints from slide film costs more, and unless your exposure is perfect, the prints don't turn out that well.

Don't leave your film in the heat as it can damage it.

Low Speed Film

■ Good In Bright Light

Bright to Average Light Level:

100 and 200 speed film can be used in bright to average lighting situations outdoors. If light level is too low, you may need to use flash or a higher speed film.

Good negative

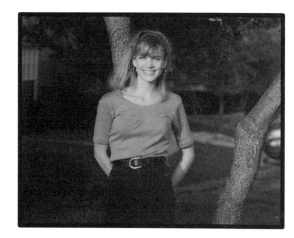

Bright light outdoors 200 speed film
Good Print

■ Bad In Low Light

Low to Very Low Light:

If you use low speed film in low light, the film will be under-exposed. Your prints will be dark and muddy looking because there isn't enough light for a low sensitivity film.

A flash can be used with low speed film to provide the light needed in low light situations.

Very thin negative
(Under-exposed)

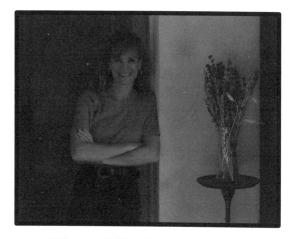

200 speed film in very low light
Print dark and muddy

High Speed Film

◼ Good In Low Light

Sensitive Film For Low Light Level:

400 and 1000 speed film are more sensitive and need less light. They can be used in low light situations where there isn't much light. * There are low light situations that have too little light for film to record.

Good negative

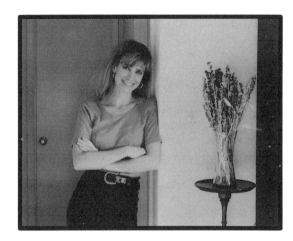

Low light indoors 1600 speed film
Good Print

◼ Bad In Bright Light

Too Much Light for High Speed Film:

If you use high speed film in bright sunlight, your film will probably be over-exposed. Your prints may be washed out in the highlights, and the color may shift toward a purple color. Adjustable cameras have more exposure range than viewfinder cameras.

Very thick negative
(Over-exposed)

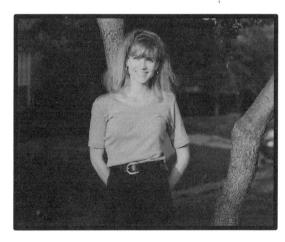

1600 speed film in bright light
Print may be lighter and color may shift

Film Speed

■ Sensitivity to Light Rating

How Much Light the Film Needs:

A films' "speed" tells you how sensitive to light it is. The more sensitive to light a film is the higher its film speed rating. The cameras meter needs to know the film speed so it knows how much light to let in. On some cameras you have to set this, others read it automatically.

Double or Half

■ Units of Light

Double = + 1 unit; Half = - 1 unit

200 speed film is double the sensitivity to light of 100 speed film but half as sensitive as 400 speed film.

Film speed, lens opening and shutter speed all are set to double or half so they can be traded with each other. They are units of light usually called a stop, (for *f* stop).

In low light you need a faster film speed especially if using a faster shutter speed or smaller lens opening.

Imagine light as water to help understand how a camera works

2 gallon jar 1 gallon jar

Need to know how much
water is needed.

Fill with amount needed
not half filled or overflowing.

2 inches 1 inch

Control amount of water with the
size of opening water comes through

2 minutes 1 minute

Control amount of water with the
length of time water comes through

You can get the same amount of water using a
2 inch hose for 1 minute or a 1 inch hose for 2 minutes.
A faster time and larger opening or a slower time and smaller opening.
(See pages 87 and 102 for reasons to want one or the other.)

Negative
or Slide Film

■ Negative Film
For Prints

Basic Rule:

Use negative film if you want to make prints of your photographs.

■ Slide Film for Slides

Basic Rule:

Use slide film if you want slides of your photographs. You can make prints from slides, but they cost more and your exposure must be perfect to get a good print.

Negative film

Print

Black and White
or Color Film

■ Film Choice

Which Do You Want:

Use Black and White film for Black and White prints. Use color film for color prints.

Slide film

Slide

Film Emulsion

■ Light Sensitive Mixture

Silver Dissolved and Sensitized:

Silver is dissolved into tiny little grains and sensitized to light. It is mixed with goop to hold it to the film. The longer it is mixed, the more the grains clump together to form bigger grains. Where light hits the film the silver grains bond to the film. Where no light hits the film, the silver washes away in the developer when the film is processed.

Bar of silver

Jar holding silver dissolved into grains mixed with goop to hold it on the film

Film Base

■ Glass vs. Plastic

Early Film vs. Today's Film:

In the early days, photographers would brush the light sensitive mixture on a piece of glass as a base to hold it. Today, machines spread the emulsion very thinly and evenly on clear plastic.

Piece of glass with emulsion brushed on it

Piece of clear plastic with emulsion spread by machine

Film Speed and Grain Size

■ Silver Grains

Light Sensitized Silver:

Tiny grains of silver make up the image in a negative.

■ Low Speed Film

Smaller Grain Size:

Low speed film has smaller grain for more detail in enlargements, but needs to be used in brighter light.

■ High Speed Film

Larger Grain Size:

High speed film has larger grain and isn't as detailed in enlargements, but it can be used for natural looking shots in low light.

Tiny section of 35mm negative from 11 x 14 enlargement

100 speed film

200 speed film

400 speed film

1600 speed film

3200 speed film

High Speed Film and Stopping Action

■ Shutter Speed not Film Speed

A Common Myth:

The statement, using a higher film speed helps stop action, is half true. A faster shutter speed stops action but lets in less light. A higher speed film needs less light which lets you use a faster shutter speed to stop action.

To prevent camera movement use 1/60th or faster when hand held.

Film Damage

■ Heat

Heat Damages Film:

Don't leave film in a hot car, direct sunlight, etc.

■ X-rays

X-rays Damage Film:

X-rays can damage film before it is processed, and repeated exposure can add up. Ask to have film hand checked in airports and don't put film in luggage where x-ray doses are highest.

The faster the shutter speed, the faster the action it stops

(A subject going past the camera needs a faster shutter speed than one coming straight at or diagonal to the camera.)

 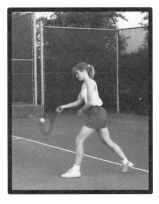 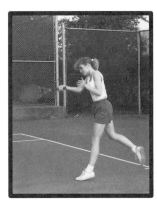

| 1/60th of a second | 1/125th of a second | 1/250th of a second | 1/500th of a second |

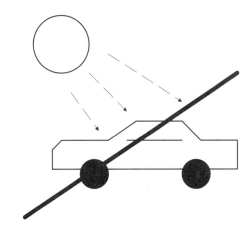

Heat Damage
Don't leave film in car
on a hot day

X-ray Damage
Don't send film in luggage
Ask to have film hand checked

Film

■ Summary

Matching Light and Film Speed:
Try to match the film's sensitivity to light to the amount of light in which you will be photographing.

Color or Black and White Film:
Choose color or black & white film according to how you want to record your subject.

Negative or Slide Film:
Use negative film if you want prints and slide film if you want slides.

Improve Your Skills

1. 100 speed film indoors
2. 100 speed film outdoors
3. 100 speed film with flash
4. 200 speed film indoors
5. 200 speed film outdoors
6. 200 speed film with flash
7. 400 speed film indoors
8. 400 speed film outdoors
9. 400 speed film with flash
10. 1000 or 1600 speed film indoors
11. 1000 or 1600 speed film outdoors
12. 1000 or 1600 speed film with flash

Mini Quiz

1. Film is made of a clear plastic _____ with a light sensitive _____ spread thinly on it.
2. The light sensitive mixture contains tiny _____ of silver.
3. The _____ the grains of silver the more sensitive the film is to light.
4. In low light you need a _____ speed film that needs less light.
5. In bright light you can use a _____ speed film that needs more light.

(1. base, emulsion 2. grains 3. larger 4. higher 5. lower)

C.A.L.L. Your Shot

■ Creative Reminder

Four Steps to Great Photographs:

C.A.L.L. is a quick easy checklist to help you think of different combinations of the basics which can lead to other creative ideas.

Which photo uses all these choices?

C: Horizontal, 1/3 crop, fill frame
A: Front, normal camera height
L: Shade at sunset
L: Telephoto lens

Try to identify the creative choices used in the other 2 photos.

Try C.A.L.L. with different subjects:

__ People	__ Travel
__ Scenic	__ Fashion
__ Pets	__ Sports
__ Cars	__ Architecture
__ Flowers	__ Children

Overall Scene

Three different combinations of creative choices

1.

3.

Composition

Crop and Format
__ *1/3* __*2/3* __ *3/3 (full)*
__ *Vertical* __ *Horizontal*
__ *Funky Tilt*

Composition
__ *Subject fills frame*
__ *Top* __ *Bottom*
__ *Left* __ *Right*

Angle

Walkaround Angle
__ *Left* __ *Right*
__ *Front* __ *Back*

Camera Height Angle
__ *Low*
__ *Normal*
__ *High*

Lighting

Type of Light
__ *Direct* __ *Backlight*
__ *Shade* __ *Diffused*

Lighting Tools
__ *Natural tools* __ *Flash*
__ *Light block* __ *Reflector*
__ *Subject placement*
__ *Time of day*

Lens

Lens Choice
__ *Wide-angle lens* ____*mm*
__ *Normal lens* ____*mm*
__ *Telephoto lens* ____*mm*

Working With a Photo Lab

Knowing what to ask for and getting good prints

A photo lab processes your film, prints it and makes enlargements. You can send it in at a grocery store, take it to a one-hour lab or use a professional lab.

Find a lab you can *work with* who will get to know how you like your prints printed. I always write on the order bag to " Print Warm and Rich with Suntanned Faces."

Make sure they *clean* their chemical tanks and keep their chemicals fresh. If the processing is bad, halation can appear on a negative in a couple of weeks. This is where some of the silver that should have been washed away is left behind. It makes it hard to get good reprints. The film can be run thru the fix again to clear it.

Take some fun shots to finish a roll and have it processed. This also lets you find sooner than later, no film in the camera, film didn't go thru, etc.

The machines at the labs should be able to match a print you already have. If they need to redo a bad print and the negative is okay, ask them to. If you are having a reprint made ask them to match or make it better than your original print.

The one hour labs can do a good job; it just depends on who is running that store. If they don't work with you, try another lab. *Try* to get what you need but don't be rude.

You need a good negative to get a good print. Fortunately, negatives do have a lot of *forgiveness* for bad exposure, and you can usually get an acceptable print.

Labs tend to print *flash* prints too light and overall, too blue. If you look in the white areas of the print, you can see if there is a tint of color suggesting the print is too blue, yellow, green, or red.

Good Negative
Good Print

■ Photo Lab Does Good

Not Too Light or Too Dark:

The photo lab should make a good print from a good negative. It should not be too light or too dark; it should be just right.

Good Negative

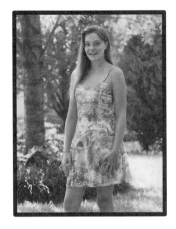

Good print

Good Negative
Bad Prints

■ Photo Lab's Mistake

Too Light or Too Dark:

If your print is too light or too dark, look at your negative. If it looks okay, ask the photolab to reprint it. Labs usually print flash photographs too light. Some people think something is wrong with their camera when their prints are too light or dark, but usually it is the photo lab.

Good Negative

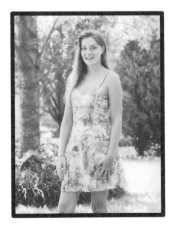

Printed too light
Needs to be redone

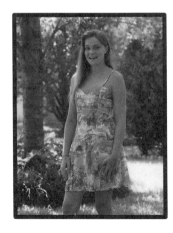

Printed too dark
Needs to be redone

Negative Under-exposed

■ Under-exposed and Way Under-exposed

Too Little Light on Negative:

A slightly under-exposed negative will print okay. If it is too underexposed the print will be dark and muddy.

Negative film can be under or over-exposed a little and still make an ok print. This forgiveness of exposure is known as the film's latitude.

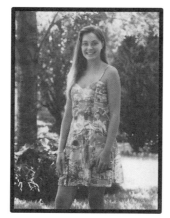

Negative a little under-exposed

Print Okay

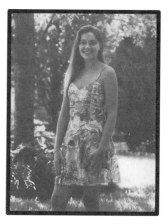

Negative way under-exposed

Print dark and muddy

Negative Over-exposed

■ Over-exposed and Way Over-exposed

Too Much Light on Negative:

A slightly over-exposed negative will print okay. If it is too overexposed it will be harder to make a good print.

(It is generally better to have a thick negative than a thin one with nothing on it.)

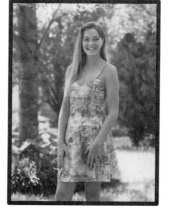

Negative a little over-exposed

Print Okay

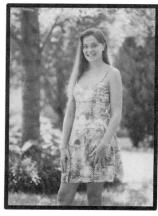

Negative way over-exposed

Print losing detail in high lights

107

Prints

■ Light or Dark Prints

Personal Taste Test:

Have a one hour lab print five test prints for density and color for about $ 5. The difference between too light and too dark can make a big difference in a print. Labs have a tendency to print too light especially on flash photos. You do need to be sure you are not closer than the minimum distance when using the flash or the negative can be over-exposed.

■ Warm or Cold Prints

I Like Warm Prints:

I ask my lab to print my color photographs warm and rich with suntanned faces. On scenics I like the warmth of sunset. Some labs tend to print cold blue tones, so you have to ask for warms ones.

Look at the white areas in the photograph to see what tint the photo has. Are they bluish, greenish, yellowish or reddish? This can help you judge what you may want changed. A lot of red in a photograph can cause an automatic printer to balance with too much blue.

Personal Taste Test for Density

Lay your five prints side by side and see if you like the lighter or darker prints.

- 2 lighter	- 1 lighter	Normal	+ 1 darker	+ 2 darker

Personal Taste Test for Color

Lay your five prints side by side and see if you like the colder or warmer prints.

- 2 colder	- 1 colder	Normal	+ 1 warmer	+ 2 warmer

Black and White Print Contrast

■ Low or High Contrast

Custom Prints:

A black and white print can be made low contrast with more grey tones or high contrast with mainly blacks and whites.

Low Contrast / More grey tones

High contrast / Less grey tones

Enlargements

■ Guide Print for Color, Density and Cropping

Good Guide Print:

If you can, leave a small sample print to show the lab the density and color you want. You can tell them to match the guide print or print lighter or darker, warmer or colder than your guide print. You can show the cropping you would like also. Make sure your negative is in sharp focus. Leave your negatives in strips as they are easier to handle.

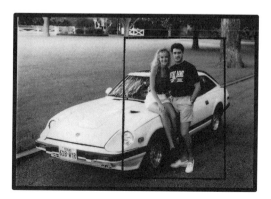

Guide print with crop marked.

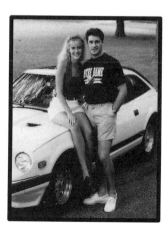

Cropped Enlargement

Usable Negative Space

■ Negative Space vs. Print Space

More Space on Negative:

When the roll is printed, the negative carrier crops out part of the negative. If you wanted something on the edge of the print for an enlargement, look at the negative; it might be there.

Negative

Carrier crops in on negative

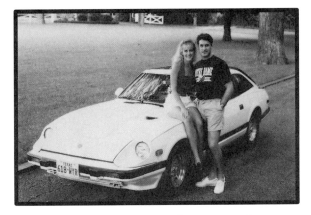

Print from negative cropped in on when roll printed

Negative Size vs. Print Size

■ Matching Proportions

35mm Negative Longer than 8x10:

A 35mm negative will enlarge to fit a 3x5, 4x6, 5x7 or 8x12 print. An 8x10, 11x14 and 16x20 print is not as proportionately long, and you will lose some of the photo on the ends of the print.

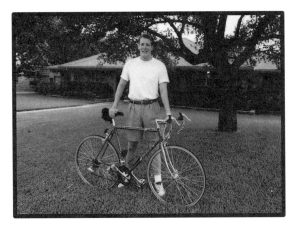

8x12 Print is longer

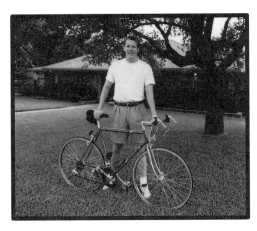

8x10 Print is shorter

Working with a Photo Lab

■ Summary

Density:

Choose a good negative and go to a one-hour photo lab. Ask them for the following: 1. a normal print 2. two prints, lighter by one and two steps 3. two prints, darker by one and two steps.

Warm or Cold:

Choose a good negative and ask for the following: 1. a normal print 2. two prints, warmer by one and two steps 3. two prints, colder by one and two steps.

Look at Negatives:

Look at your negatives to make sure they are ok. A reprint or enlargement should be able to match an existing print.

Flash Photographs:

Labs usually print flash photos too light, so ask for them again if the negative looks okay. You don't want them too dark either.

Improve Your Skills

1. Have lab make a normal print
2. A print one step darker
3. A print two steps darker
4. A print one step lighter
5. A print two steps lighter
6. A print one step warmer
7. A print two steps warmer
8. A print one step colder
9. A print two steps colder
10. Choose your favorite density for prints
11. Choose your favorite color shift for prints
12. Choose combination you like best

Mini Quiz

1. When you get a bad print it could be your _____ or it could be the photo lab. If your negative is good, ask the lab if they will reprint it.

2. Flash pictures can often be printed too _____, but be careful not to get closer than the minimum flash distance with your camera.

3. Look in the _____ areas to see if there is a color shift toward warm or cold tones.

4. The lab can _____ your negative when making an enlargement.

5. Try to let the ____ know how you like your prints and leave one as a guide print to match or change from.

(*1. negative 2. light 3. white 4. crop 5. lab*)

Buying a Camera

Viewfinder Cameras
Helpful buying information

1. You look through a viewfinder not the lens and can't change lenses

2. Smaller and more convenient but less creative control than SLR

Viewfinder Cost

Disposable cameras	$ 8. - 15.
Point and shoot camera with wide angle lens	25. - 90.
Point and shoot camera with dual zoom lens settings, zooms to either wide angle or telephoto lens	110. - 140.
Point and shoot camera with continuous zoom lens from wide angle to telephoto	160. - 400.

Options (All options available on SLR cameras too)

__Autowind and rewind

__Built-in flash located far from lens or red eye reduction

__Date and time on film

__Backlight button

__Spot meter

__Autofocus

__Macro capability

__Weather proof and under water capability

__Stronger zoom lens

__Self timer or remote control

__ Auto read for film speed

__ Won't shoot if no film in camera or if film isn't going through camera

(Read your camera's manual and learn what it can do. If it's lost, call or write the manufacturer for a new one, usually only a couple of dollars.)

SLR Adjustable Cameras
Helpful buying information

1. You can look through the lens and change lenses

2. More creative controls but larger and less convenient than viewfinder

Single-lens Reflex Cost

Camera body	$ 200. and up
Camera lens	$ 125. and up

Camera Creative Controls

Program: Camera sets everything for you like a viewfinder camera.

Custom Programs: *Sports*-stop action; *Portrait*-blur background; *Scenic*-background sharper; *Macro*-closeups

Automatic: You set one setting and the camera sets the other for you.

 Shutter priority: Set the shutter speed you want and the camera sets the lens opening automatically for you.

 Aperture priority: You set the lens opening and the camera automatically sets the shutter speed for you.

Manual: You set both lens opening and shutter speed settings.

Note: If you want to stop action, set the shutter speed first. If you want to blur the background or make it sharp, set the lens opening first. Make sure the exposure is balanced by the other setting.

Options

__Flash built into camera or a dedicated flash that is totally automatic

__Self timer or radio remote for camera or flash

__Autofocus and autotracking for moving objects

__Motor drive, continuous sequence and autorewind

__ Spot meter, or a backlight button

Edit, File & Display Your Photographs

Filing avoids frustration, simply use the year and roll number

Editing your photographs when you get them back from the lab is a job. You have to *decide* which ones to put in the photo album, which ones to file with the negatives, which ones to get reprints for family and friends and which ones to get enlargements of for display.

Assign a number to each roll and record it with the year on a blank piece of the plastic on the negative sleeve. Record the *year and roll #* on the back of each print for that roll.

You may want to record the negative numbers on the prints when you first get them back before the prints get out of order. It can make finding the negatives easier later on.

Additional information on the back of the print about the people, place and date can help you remember later on.

I prefer using a *ball-point pen* to write lightly on the backs of the prints more than felt tip or pencil.

Keep your negatives. Your original negative will always be better than a negative made from copying a print. Prints can fade and turn yellow. Even if you have a video made of the photographs, keep the negatives and prints because videotape wears out.

If you already have lots of negatives and prints that need, editing and filing, set aside an afternoon and the supplies you will need and go for it. Some people will need *two afternoons.*

Easel frames can be set around the house. Wall frames can be hung around the house. You can make a gallery on a wall if you like.

Standard Print Sizes:

2 x 3

3 1/2 x 5

4 x 6

5 x 7

8 x 10

8 x 12

11 x 14

16 x 20

20 x 24

24 x 30

30 x 40

40 x 60

Year - Roll

■ Simple Filing System

92-3 = The Third Roll Taken in 1992:

Write the year and a roll # on an empty part of the plastic sheet that the negatives come in. Write the year-roll number on the back of the prints for that roll. Each new year you can start with roll 1 again. Recording the negative # helps if people are ordering prints. You may want to record the subject and events on the back of some of the prints also. I prefer a ballpoint pen to write gently on the back of the prints.

92-3

Judy, Alan & Ann

Write year & roll number on back of prints
(Other information is optional)

12

Negatives have numbers to
make ordering easier

Filing Negatives

■ Year, Roll Number
and Description

Negative Filing Envelopes:

File negatives and undisplayed prints in an envelope with the month, year and subjects written in the upper right hand corner. File the negative envelopes in a shoe box by the year.

92-3

Vacation and Birthday Party

Write information on negative envelope

1991 and 1992

Photographs & Negatives

Write information on filing box

Photo Album Pages

■ Page Styles

Lay Down or Slip In Pages:

Some albums have protective plastic over paper pages to let you position the photographs and write notes. Other albums have slots into which you slip the photographs.

■ Archival Pages

Help Keep Photos from Fading:

Archival albums and pages have less chemicals in them that might fade your photographs. Keep your photographs out of direct sunlight and heat because that will fade them also.

Album with paper pages
and protective plastic

Album with slots
for photographs

Easel Frames

■ Set Around House

Small Prints:

Easel frames usually hold small prints and can be set on desks, dressers, shelves, etc.

Front view of frame

Side View of Frame

Frame Crops in on Print

■ 1/4 Inch Off Each Edge

Position Print in Frame:

The lip of the frame that holds the print in is generally 1/4 inch. Smaller prints lose more space. A five by seven frame actually has a 4 1/2 x 6 1/2 opening for the print.

Print

Lip of frame crops 1/4 inch off each edge

Wall Display

■ Wall Space Size and Viewing Distance

Where to Hang Print:

How big is the wall space and how big would the print need to be? Can other things help to fill that space? How about a collage of photographs?

Normal Viewing Distance of Print:

In a hallway, viewing distance is three feet, in a room it may be 15 feet.

Wall space too large for print

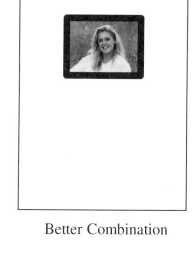

Better Combination

Frame or Mat

■ Displaying Print

Mount prints larger than 16 x 20:

You can mount your photograph directly into a frame or mat and frame it. I prefer glare glass. Some art galleries have special glass that helps prevent fading.

Artists Signature:

You should sign and date your photograph or mat.

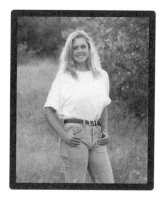

Print Framed

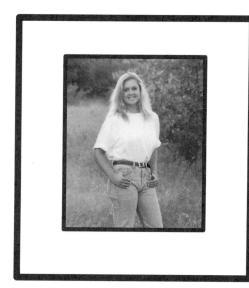

Print Matted and framed

Recipe Cards for Photographs

■ Record Information

Be able to Repeat Recipe:

Keep a card file of favorite photographs and how you took them. Paste the card to the back of the print with the information. You can refer back to the file to help you when creating a similar photograph. It's kind of like a cake recipe.

Subject:

Crop:

Composition:

Walk-Around Angle:

Camera Height:

Lighting:

Time of Day:

Lighting Tools:

Film Speed:

Lens Choice:

Subject: *Portrait with car*

Crop: *Full length, horizontal*

Composition: *Fills the frame*

Walk-Around Angle: *Nondistracting*

Camera Height: *Normal / Untilted*

Lighting: *Backlighting*

Time of Day: *Early morning*

Lighting Tools: *Backlighting*

Film Speed: 200 *speed film*

Lens Choice: *Telephoto*

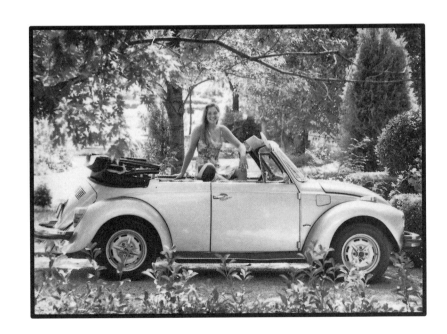

Organizing Your Old Photographs and Negatives

■ Summary

1. Get Boxes and Envelopes:

Get enough boxes to hold the negatives with dividers for the years. Get enough filing envelopes for the negatives.

2. Year & Roll # on Negatives:

Record year and assign roll # to each group of negatives and the year and roll # on the prints.

3. Choose Prints for Display:

You may want to set out some of the photographs to put in an album, a frame or to have an enlargement made.

4. Places to Display:

Make a list of places to display photographs in your home.

* Keep your negatives. They don't take much space in a shoe box and lost or faded prints can be reprinted from them. You lose quality if you have to copy a print.

Assignment

File old and new negatives and prints.

Boxes for filing

Envelopes for filing

Year and roll number on plastic negative sheet and on back of prints

92-3

92-3
Judy's Birthday Party

Year, Roll # and Subject on Negative envelope

A Quick Overall Lesson

**On one roll of
36 exposure film**

Composition

1 Vertical format
2. Horizontal format
3. Funky Tilt format
4. Crop 3/3 (full length)
5 Crop 2/3
6. Crop 1/3
7. Place on left or right third
8. Place on top or bottom third
9. Place subject on Hot Spot

Angle

10 Subject from front
11 Subject from left side
12 Subject from back
13 Subject from right side
14 Subject from low angle
15 Subject from normal angle
16 Subject from high angle

Lighting

17 Subject in direct sunlight
18 Subject in backlight
19 Place subject in shade
20 Place subject under overhang
21 Subject with flash
22 Subject with reflector
23 Place subject in direct light with background in shade
24 Place subject in shade with background in shade
25 Place subject in shade with background in direct light
26 Subject at sunrise
27 Subject in morning
28 Subject at noon

Lens

29 Subject with wide-angle lens: Same distance
30 Subject with telephoto lens: Same distance
31 Subject with wide-angle: Same image size
32 Subject with telephoto: Same image size
33 Subject from high angle with telephoto
34 Subject from low angle with telephoto
35 Subject from high angle with wide-angle lens
36 Subject from low angle with wide-angle lens

Quick Review

A brief one-page visual summary of each chapter

1. Cropping and Composition: Choose a *format* for your photograph, vertical, horizontal or at a funk tilt. Decide how much of the subject and background you want to show and *crop* it by thirds. Place the subject in the photograph using thirds for *composition*.

2. *Walk-around* your subject to look at different angles on the subject, background and lighting.

3. Look at different camera *heights* to the subject from low, normal and high angles.

4. See which of the *four* types of lighting you have to work with.

5. The *time* of day will affect the lighting on your subject.

6. Try to get the best lighting *ratio* on your subject and between your subject and the background.

7. Use light tools to control the light both portable and the surroundings.

8. Use your *flash* to provide the main light when there is not enough light to take a photograph. Use a flash as a fill light to fill in shadows and give a lower angle to the light.

9. There is a big difference between a wide angle and a telephoto *lens*. Choose the look you want and walk to get the view you need.

10. Choose your *film* speed according to the amount of light you will be photographing in. Use low speed film for bright light and high speed film for low light.

11. Look at your negative if you get a bad print from the photo *lab*. A good negative deserves a good print.

12. Spend a little time to *number* your negative roll and prints. It's easy to do and saves frustration.

Cropping & Composition

■ **Choose a Format:** *Vertical, Horizontal, or Funky Tilt*
Crop: *How much to show*
Composition: *Where to place your subject.*

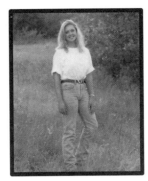
Vertical crop

Horizontal crop

Funky Tilt crop

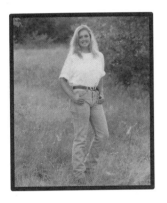
3/3 Crop (Full length)

2/3 Crop

1/3 Crop

Crop in for details

Don't center subject in focus circle

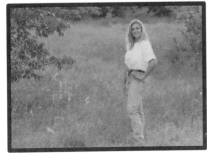
Left or right 1/3 line

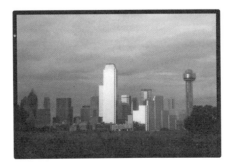
Top or bottom 1/3 line

Hot Spots where 1/3 lines cross

Walk Around Camera Angles

■ **Walk around the subject looking at different angles.**

Back

Left Side

Right Side

Front

Camera Height

■ **Look at the subject from low, normal and high angles.**

High

Normal

Low

Find the best camera angle for the
Lighting, Background and Subject

4 Types of Light

■ **Identify the types of light you have to work with.**

Direct Light: Sun in front of subject

Backlight: Sun behind subject

Clouds

Sunrise & Sunset

Shade: Sunlight blocked by an object creates shade

Diffused Light: Sunlight softened by clouds or the atmosphere

Time of Day
and Angle of Light

■ The time of day affects the
angle of light on the subject
and background.

Noon

Late morning

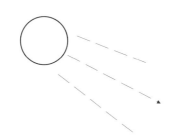

Early morning

Sunrise

Lighting Ratio

■ **Look at the lighting ratio on your subject and between the subject and background.**

Subject
Light Ratio

Low lighting ratio

High lighting ratio

Subject to Background
Light Ratio

Low lighting ratio

High lighting ratio

Lighting Tools

■ **Identify the lighting tools you can use to control the light.**

Using camera angle to create backlighting

Using shade from surroundings

Using an overhang from surroundings

Using reflectors from surroundings

Using portable flash

Using portable shade

Using portable overhang

Using portable reflector

Flash

■ **Flash can be used as the main light or a fill light.**

Main light

Not enough light to shoot

Flash provides light to shoot

Fill light

Harsh shadows

Flash fills in shadows and gives good direction to the light

Lens Basics

■ **There is a big difference between wide-angle and telephoto lenses.**

Same distance from subject

Different coverage of subject

Wide-angle Lens

1. Pushes subject away
2. Wider coverage
3. Shows more area

Telephoto Lens

1. Brings subject closer
2. Narrower coverage
3. Shows less area

Same coverage of subject

Different distance from subject

Wide-angle Lens

1. Shows more background area
2. Shorter working distance
3. Expands scene & more depth of focus

Telephoto Lens

1. Shows less background area
2. Longer working distance
3. Compresses scene & less depth of focus

Film

■ **The higher the film speed the more sensitive to light it is.**

Bright to average light
100 or 200 speed film

Low light to very low light
400 or 1600 speed film

Buy slide film for slides

Buy negative film for prints

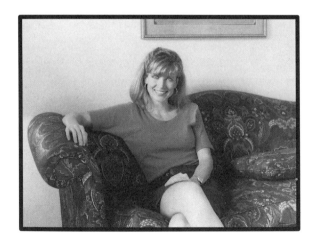

Working with a Lab

■ **Make sure you have a good negative and then make sure you get a good print.**

Three prints from a good negative

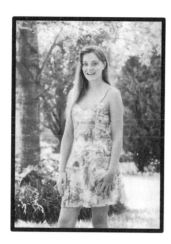 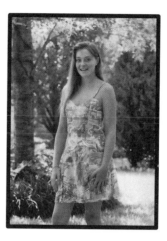 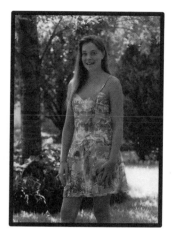

Printed too light
Needs to be reprinted

Good print

Printed too dark
Needs to be reprinted

Under-exposed, Good and Over-exposed Negatives

Negative very thin
hard to print

Negative a little thin
but okay

Good Negative

Negative a little thick
but okay

Negative very thick
hard to print

Filing and Displaying Photographs

■ **Spend some time to organize your negatives and photographs and you'll enjoy them more.**

Albums to display prints

Easel frames

Wall frames

90, 91, and 92

Boxes to file negatives

92-3

Vacation

Envelopes to file negatives and extra prints

92-3

Information written on back of prints

Photography Dictionary

Backlighting: Sun behind the subject, can be identified by rim of light on edge of subject.

Camera Height: The height of the camera to the subject.

Composition: Where you place the subject and other objects in the photograph.

Cropping: How much you show of the subject and other objects in the photograph.

Direct Sunlight: Sun in front of the subject, usually a harsh light.

Diffused Light: Sunlight softened by passing through clouds or atmosphere.

Easel Frames: Small frames with easel backs to set them on things around the house.

Film: A piece of plastic with a light sensitive mixture spread on it.

Film Processing: The process where chemicals remove the unexposed silver and then fix or stop the developing process and stop the negative's sensitivity to light.

Film Speed: A film's sensitivity-to-light rating. The higher the rating the more sensitive to light a film is.

Filters: A filter put in front of the lens will change the photograph, how depends on the filter you use.

Flash: An electronic device that produces a burst of light you can use when you need more light on your subject.

Indirect Light: Light that is not directly from the sun and is shaded, reflected or diffused before reaching the subject.

Lens: A tube with glass in it that helps the camera focus the light on your film.

Lighting Tools: Anything that blocks, redirects or reflects the light on your subject.

Macro Lens: A lens that lets you take closeup photographs of objects and magnifies them.

Negative Film: Negative film produces a negative or reverse image. It is good to make prints from and has better exposure latitude than slide film.

Overhang: It blocks the light above the subject, redirecting the light to a lower angle for your subject.

Photo Album: It holds photographs and memories to be viewed and enjoyed.

Print Density: How light or dark a print is.

Over Exposure: Too much light on the negative; a thick dark negative.

Reflector: It reflects light off its surface and can be natural like sand and snow, or man-made like a white wall or piece of cardboard.

Shade: An area where direct sunlight is blocked by another object.

Slide Film: Slide film produces a positive image and can be viewed as a slide. Prints can be made from it but it has less latitude than a negative. It is also called a chrome or transparency.

Telephoto Lens: A longer lens that brings the subject and surrounding area closer and shows less background.

Under Exposure: Not enough light on the negative; produces a thin light negative.

Walk-Around Camera Angle: The different angles you see of the subject, background and lighting as you walk around your subject.

Wall Frames & Mats: A frame to hang on the wall and a mat to surround it and fill a larger frame.

Wide-angle Lens: A shorter lens that pushes the subject away and shows more background and surrounding area.

Zoom Lens: A lens that can be made longer or shorter to become a wide angle or telephoto.

Working with People

■ Encourage don't Criticize

Create a Relaxed Atmosphere:

If you can make people feel good their expressions will be good. Fake expressions happen when they don't feel it inside. Tell them they are doing great and encourage them. Criticism makes people freeze up. Try a variety of expressions and feelings from laughter to serious, looking at the camera and looking away.

■ No Pose vs. Posed vs. Too Posed

Natural and Comfortable:

People generally need help posing. Direction to turn or tilt the head or turn the body helps. Try to pose and arrange people so it looks like it happened naturally. Work with people for a relaxed feeling so their poses aren't stiff and over posed. You can have fun just letting people goof off in front of the camera. Using a telephoto lens gives you a longer, more comfortable working distance for your subject.

Helping people feel good in front of a camera is a skill.

| Forced smile on face not from feeling inside | Laughing smile from fun feeling inside | Relaxed smile from relaxed feeling inside | Don't have to smile or look at camera |

Helping people pose naturally in front of a camera is a skill.

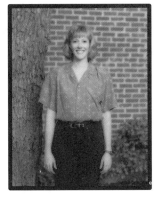 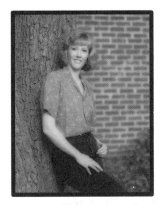 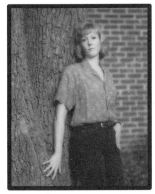 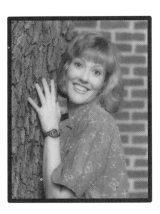

| Standing there with no posing | Relaxed posing with natural feeling | Too posed with unnatural feeling | Fun posing just goofing around |

Questions & Answers

1. What are common mistakes in cropping and composition?
Centering the subject in the focus circle and putting the horizon in the middle of the photograph.

2. What are common mistakes in camera angle?
Not taking a few steps around the subject to look at different angles, and shooting everything from a standing position never changing the camera height.

3. What are common mistakes in lighting?
Not knowing what the different types of lighting are and shooting most things in direct sunlight with harsh shadows.

4. Do I need fancy equipment to work with lighting?
No, you can use objects around you to redirect the light, overhangs, shade, sand, changing camera angle to backlight subject, etc. You can also use hand-held reflectors, light blocks or a flash to redirect the light.

5. What causes red eye?
The flash located too close to the lens causes the light to reflect off the blood vessels in the eyes straight back into the lens. Locating the flash further from the lens prevents this. You need two inches between the flash and lens for every five feet you are from your subject.

6. How far away will my flash work?
The maximum working distance for most cameras with a built in flash is about 12 feet using 100 speed film. The minimum distance is about four feet. The higher the film speed, the farther the maximum and minimum working distances.

7. Should I use my flash outdoors?
If it is dark outside you need it, but even on a bright day it can balance the shadows and give a good direction to the light.

8. What film should I use?
In bright light you can use a slower speed film like 100 or 200. In low light you may need a faster speed film like 400, 1000 or 1600.

9. Which lens should I use?
To show more in a small space, you may want a wide-angle lens. To bring something closer, or for a portrait, you may want a telephoto lens.

10. Where should I take my film for processing?
Make sure the lab keeps its chemicals fresh and cleans out the tanks and machine weekly. Different labs have different managers and people working at them, and that can make a difference.

11. How do I organize my negatives?
The simplest way is to organize them by year. Number each roll of negatives with the year and then 1 through how many you shoot that year. Write this number on the backs of the proofs from that year. Example: 92-4 = Year: 1992 Roll number: 4

12. How helpful is it to go back and look at photos I've taken?
It can be very helpful to see the different things you could have improved on and the areas you want to work on. It is an excellent learning experience.

To order additional copies of this book

Do you know friends or relatives who would enjoy a copy of this book? If so, fill out the information below and send it to us with a check or money order and we'll be happy to send the books to you.

Phillips Lane Publishing

5430 LBJ Freeway, Suite 1600

Dallas, Texas 75240

Books may be ordered by phone using Mastercard and VISA. Please have your credit card information ready when calling to place your order. Thank you.

1-800-4-PHOTO-4

(1-800-474-6864)

(Volume discounts are available for schools, photography clubs and other organizations.)

Name:_____

Address:_____

City:_____State:_____Zip:_____

Please send me _____ book(s) at 17.95 each $ _____._____

Texas residents add 8.25 % sales tax, $1.48 per book $ _____._____

Add 3.00 for shipping and handling for first book $ _____._____

Additional books add 1.50 shipping and handling $ _____._____

Total Enclosed $ _____._____

Name:_____

Address:_____

City:_____State:_____Zip:_____

Please send me _____ book(s) at 17.95 each $ _____._____

Texas residents add 8.25 % sales tax, $1.48 per book $ _____._____

Add 3.00 for shipping and handling for first book $ _____._____

Additional books add 1.50 shipping and handling $ _____._____

Total Enclosed $ _____._____